OLD MILWAUKEE

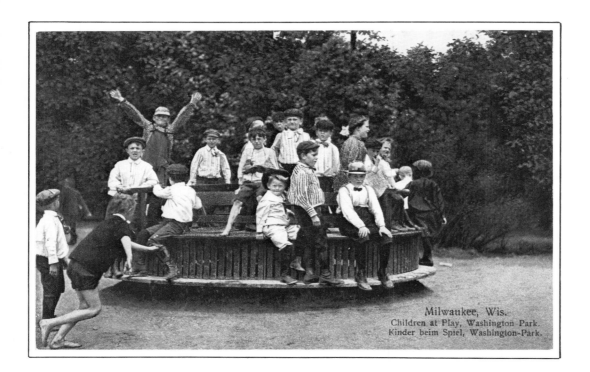

Milwaukee, Wis.
Children at Play, Washington Park.
Kinder beim Spiel, Washington-Park.

The Germans and Poles who were the major population groups in the early development of Milwaukee brought with them from Europe a strong work ethic which assured the success of the community as a major economic force in America's Midwest. But with hard work comes a need for opportunities for play, and the city planners of the early days were careful to provide fine parks and recreational facilities for young and old alike.

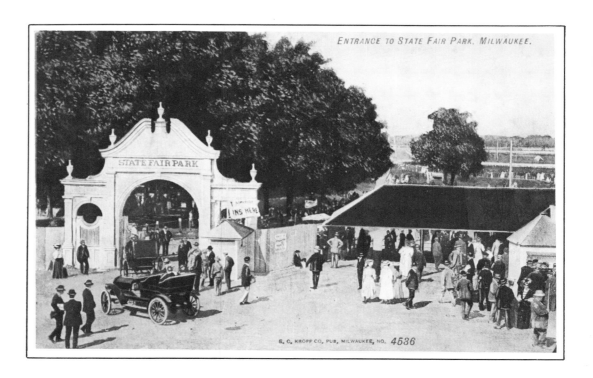

ENTRANCE TO STATE FAIR PARK, MILWAUKEE.

STATE FAIR PARK

E. C. KROPP CO. PUB, MILWAUKEE, NO. 4536

OLD MILWAUKEE

A Historic Tour in Picture Postcards

by Gregory Filardo

Vestal
Press

The Vestal Press Ltd.
Vestal, New York 13851

Library of Congress Cataloging-in-Publication Data

Filardo, Gregory, 1949-
 Old Milwaukee : a historic tour in picture postcards / by Gregory
Filardo.
 p. cm.
 Includes index.
 ISBN 0-911572-73-2 :
 1. Milwaukee (Wis.)—History—Pictorial works. 2. Milwaukee
(Wis.)—Description—Views. 3. Milwaukee (Wis.)—Description—
Tours. 4. Postcards—Wisconsin—Milwaukee. I. Title.
F589.M643F55 1988
977.5'95042—dc 19 88-26170
 CIP

FOREWORD

Postcards provide a fascinating way of studying the history of a city. They became popular in the United States after 1893, when the Columbian Exposition made them a matter of public fancy, and their use actually became somewhat of a craze around the turn of the century.

We're fortunate that this happened, because it insured that many scenes would be captured for posterity in a way that would probably never have happened otherwise. Not only were cards of standard scenes printed and distributed in large quantities by a wide variety of publishers to be sold in every souvenir stand and drug store in the community at hand, but enterprising photographers would catch scenes of special, short-term interest such as fires and disasters and would print them on special post-card printing paper provided by Kodak and other film makers. These were sold wherever the seller could find a market; today they're called "photo cards" and are highly prized by post-card collecting enthusiasts because of unusual scenes they frequently feature, and because of their rarity.

Indeed, in recent years the collecting and study of post cards has become a significant hobby across America, with clubs being formed, magazines and newsletters being produced, and many dealers profiting from all the activity through their buying and selling efforts to the literally hundreds of thousands of folks who find them fascinating.

Post card buffs often enjoy the study of particular publishers and their lines, often attempting to collect an entire series for which the originator was known . . . or they may specialize in a particular topic, such as railroads, or amusement parks. But whatever the motive, it's great fun for any of us to look back over the years to see how our country has developed.

One handy aspect of old post cards is that they're the same size, 3 ½ x 6 inches, a factor which serves to make them manageable when collected in substantial numbers. And it makes books like this easy to organize! Readers of this volume will note that some early cards have messages penned on the face of the card, and this is because U.S. Postal Regulations did not permit a message on the back of the card, accompanying the address, until 1907 or thereabouts.

But one needn't be a post card buff to enjoy the scenes of a fine city like Milwaukee, with so many of its citizens and residents appreciative of its history and the many wonderful buildings that have been here — and the surprising number that remain. Fortunately, Milwaukee was spared much of the wholesale destruction of downtown buildings under the banner of "Urban Renewal" that affected so many American cities in recent years.

The two-hundred or so cards in this book represent only a sampling of the literally thousands that Greg Filardo has acquired of Milwaukee scenes, and he's tried to select the most interesting ones of from this great personal collection. And it has been just as much fun for me to help assemble the book, as it has for him to prepare this little "tour" for his readers!

Harvey Roehl, editor
The Vestal Press Ltd.
Vestal, New York
1988

INTRODUCTION

I hope that you will enjoy this collection of views of "Old Milwaukee." Instead of just an assortment of views, I have attempted to present an actual tour by organizing these turn-of-the- century post cards as if one were actually travelling the streets, starting at the lakefront and then progressing to the outlying areas.

Old timers reminisce about the "good old days." What better way to visit them but through penny post cards published by the millions and sent between friends at the turn of the century. From my personal collection of several thousand different views of Milwaukee accumulated over the past twenty-five years, I have selected representative views from the 1900 to 1925 era.

Milwaukee at this time was considered by some as the "Athens" of the new world; it was in many ways the most European of any city found in America. With Lake Michigan as its eastern boundary and the Milwaukee River cutting through the center of its downtown district, the genesis for a most beautiful city was present. As the city developed, planners included stately parks, squares, and fountains, and this concern for aesthetics attracted many fine artists and craftsmen. Woodwork was shipped natiowide and still can be found in the House of Representatives' chambers in Washington, D.C. One of the finest wrought iron workers to live in the United States settled here; the works of Cyril Colnik can be found throughout the country and his iron still graces several Milwaukee structures. Milwaukee's stained glass is noted for its brilliant color and design. One unique feature of this city was its brick. A deposit of clay found here, when fired, produced bricks of a cream color, resulting in Milwaukee's becoming known as the "Cream City" because so many buildings were constructed of it. Milwaukee had many large industries which shipped products world wide and it was one of the brewery capitals of the world. At one time it was thought that Milwaukee would eclipse Chicago and become the trade center of the Great Lakes.

Times change and in man's blind rush toward the future, a sense of direction can be lost. Many cities have lost their architectural heritage through "urban renewal." Old buildings come down with little thought for the past. Except for parts of buildings reused in new structures on their sites, the bulldozers of today's technology completely remove any trace of past structures and a record of our past is irretrievably destroyed.

Does history live only in old dusty books sitting on out-of-the-way shelves? What if we could go back in time? What were things really like? By arranging these cards in a viewing order, it is possible in one's mind to go back in time and walk the same streets. Amazingly, in Milwaukee's case, about fifty percent of what is presented in this book is still standing.

As you travel through the following pages, look for architectural details — the closer you look, the more you will find. Come and visit our city; walk the streets with this book as your guide to a magical trip back in time to Milwaukee of the Turn of the Century. See if you can find the exact location where a photographer of long ago placed his camera and "froze in time" the particular view reproduced. Stay in some of the same hotels, visit the theatres, restaurants and public buildings and transport yourself into the picture in front of you. Many of these views afford rare glimpses of first-, second-, or third-generation buildings, some of which no longer exist. By locating remaining structures it is possible to "fill in" vacant lots or "dematerialize" new structures, thus performing your own urban archeological exploration.

It is hoped that you will gain an appreciation for what is still here and realize what has been lost. During the "Dark Ages" of the 1950's and 1960's many of our cities' distinctive features were lost forever. Ornamental design became a victim of modernization, cost, and uniformity. What greater homage to our native homelands could we pay than to preserve buildings in remembrance of our ancestry or roots? As we reach for the stars let us not forget where we came from.

Join with me, as have Gretch Colnik, daughter of ironmaster Cyril Colnik, and Frank Zeidler, Mayor of the city from 1948 to 1960, and the many others who have shared my enthusiasm for viewing our city's past through these post card scenes. We invite you to come and journey with us back in time to discover a wonderful place!

Gregory Filardo
July 1988

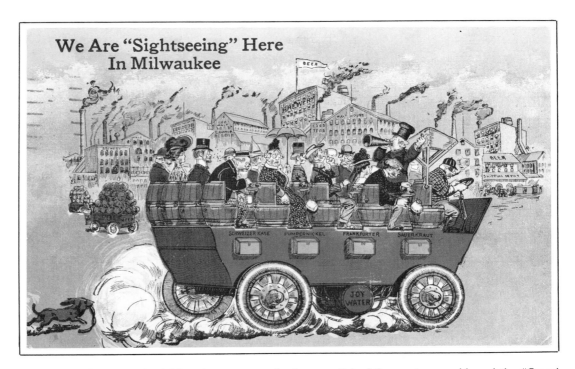

Welcome and hop aboard for a tour of Old Milwaukee! The city was once the beer capital of the western world, and the "Grand German Tradition" of Old World hospitality holds as true today as it did when these early-day visitors saw the sights on a mythical bus with seats made from beer kegs. Little Fritz, the dachshund, is having a time catching up, what with his string of tasty frankfurters in tow.

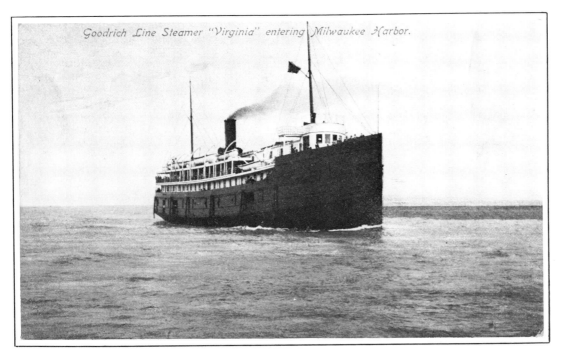

Milwaukee is an important inland port, with ships from all over the world docking in its harbor. In past years a great number of sight-seeing boats ran between Milwaukee, Chicago, and other lake ports; the Goodrich Line's steamer "Virginia" was one of the best known of these in the early days of the 20th century.

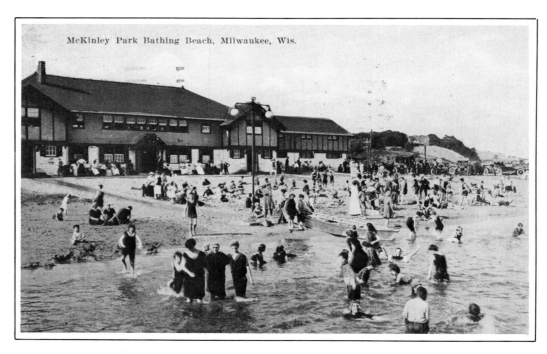

McKinley Park Bathing Beach, Milwaukee, Wis.

Thanks to the sandy beaches of Lake Michigan, local folks always have had a wonderful chance to cool off on hot days before air conditioning was invented and home pools became common. The bath house at McKinley Park Bathing Beach, a few blocks north of where the Chicago and Northwestern Railway depot stood, was demolished in the 1920's, but plenty of fine beaches remain on the lake front. Haven't bathing costumes changed!

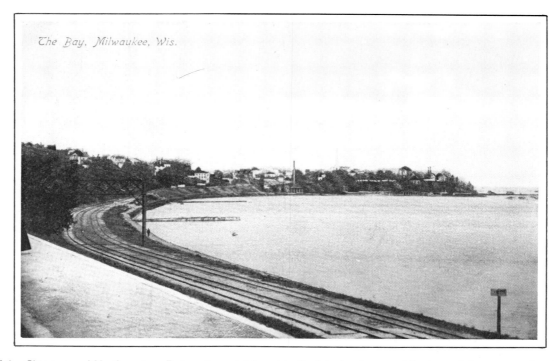

The Bay, Milwaukee, Wis.

The tracks of the Chicago and Northwestern Railroad ran right next to the lake back around the turn of the century. During the 1920's and 30's this area was filled in to make several lagoons and Lincoln Memorial Drive.

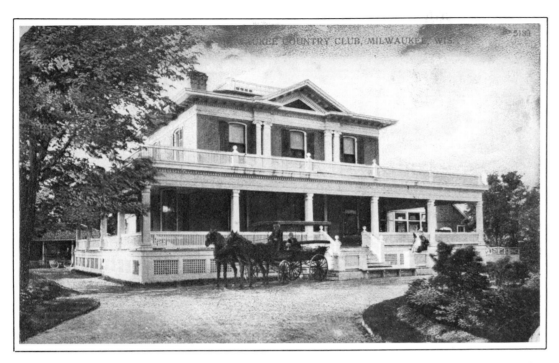

This handsome structure is the first club house of the Milwaukee Country Club, organized in 1895 — and it's where golf was introduced in the state of Wisconsin, with a six-hole course using bamboo poles for flag sticks. Eventually it was enlarged, and in 1929 was relocated at River Hills where today it continues to provide great satisfaction for those whose ultimate pleasure involves batting the little white ball around the links.

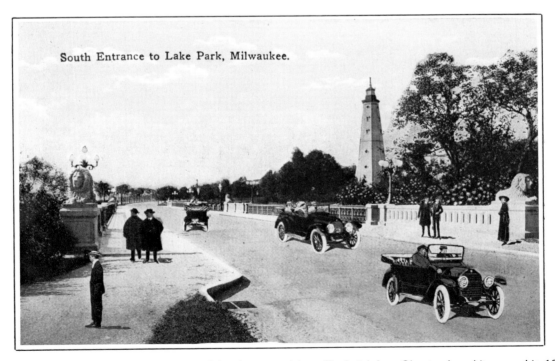

Lake Park was designed by the nationally known park landscape architect, Frederick Law Olmstead, and it opened in 1889. The stone lions sculpted by P. Kupper keep watchful eyes on those who enter and leave by this south entrance, but they are no longer concerned with auto traffic as the bridge was closed to motor vehicles in 1968. Among other features of this beautiful park is an Indian burial mound. The lighthouse, built in 1879 for the protection of seafarers on Lake Michigan, was enhanced by a thirty-six-foot addition in 1912 — and the dividing line is clearly seen in this view. The beam from its powerful light can be seen twenty-five miles from shore.

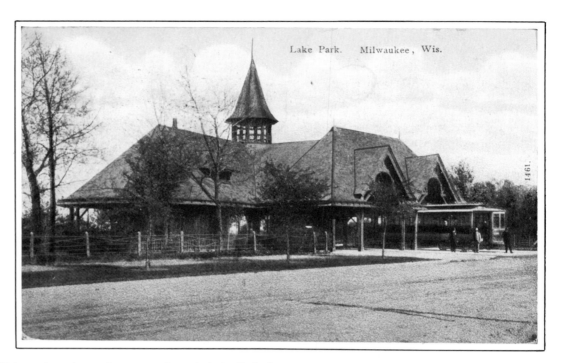

This is the Folsom (now Locust) streetcar depot in Lake Park. Constructed in the early 1890's, this was one of the most outlying runs of the new electrically-operated mode of transportation which began operation in the city in 1890. Streetcars in the far reaches of the city ran on the hour from eleven in the morning until nine at night.
hnr

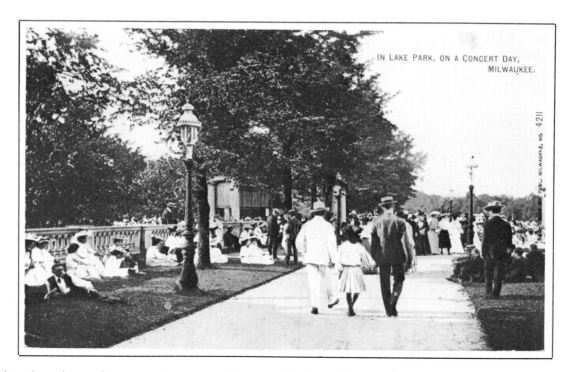

Lake Park has always been a favorite picnic spot, as well as a dandy place to hear an afternoon concert. Note the gas lights in this early view. Those were the days when the men's haberdashery business flourished, as no gentleman was ever without a hat — in nice weather, typically a panama or a hard-straw 'skimmer'.

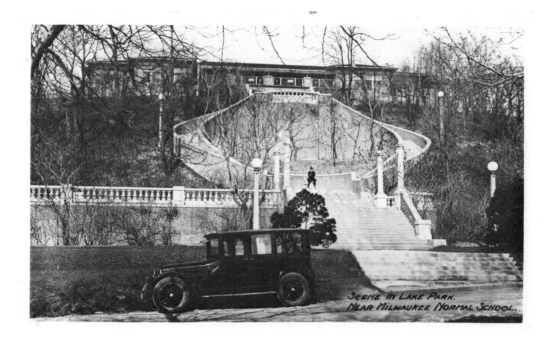

Architects Ferry and Clas designed the Lake Park Pavilion in 1903, and many graduation ceremonies and other types of formal gatherings were held within its confines. The electric street lamps of 1915 vintage with their frosted globes can be seen on these streets today. This scene probably dates back to the early 1920's, judging by the style of the car; closed-body automobiles were beginning to become popular at that time.

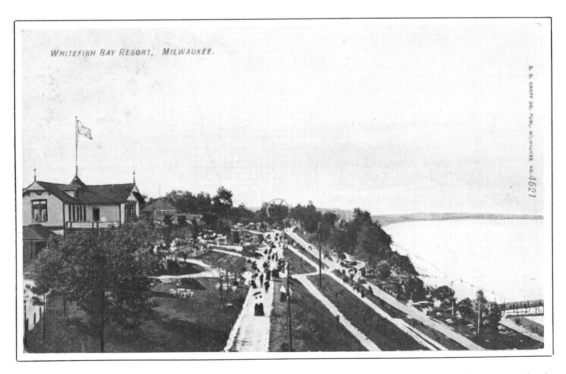

Several of Milwaukee's breweries bought large tracts of land and opened them as parks where their particular brand of beer was promoted to the public. Pabst Whitefish Bay Resort was one of these; it opened in 1889 and lasted until 1914. In addition to the beer garden and hall, there was a Ferris Wheel as well as other amusement rides. The magnificent mansion of Herman Uihlein which cost several million dollars to build in the 1915-18 era occupies part of this site at 5270 N. Lake Drive; he was one of the directors of the rival Schlitz brewery. Designed in the Italian Renaissance style, its wrought iron staircase which took Cyril Colnik three years to fabricate is considered one of the finest in the United States. The curved wood hand rail for this set of steps was made by a man who some ten years in the future would make the propeller for Charles Lindbergh's "Spirit of St. Louis" in which the young aviator gained world-wide fame by making the first solo crossing of the Atlantic Ocean.

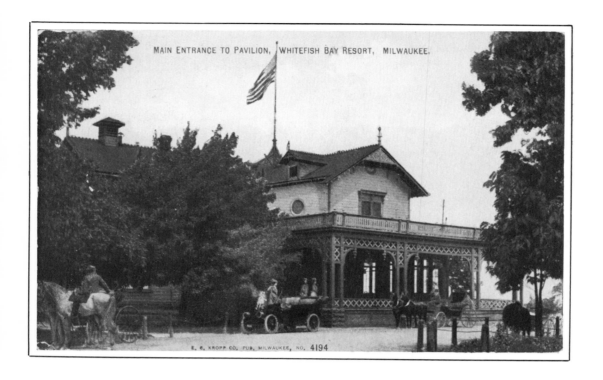

MAIN ENTRANCE TO PAVILION, WHITEFISH BAY RESORT, MILWAUKEE.

E. C. KROPP CO. PUB. MILWAUKEE, NO. 4194

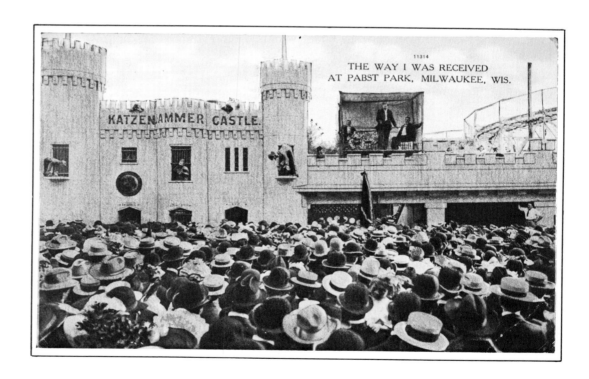

KATZENJAMMER CASTLE.

11314
THE WAY I WAS RECEIVED
AT PABST PARK, MILWAUKEE, WIS.

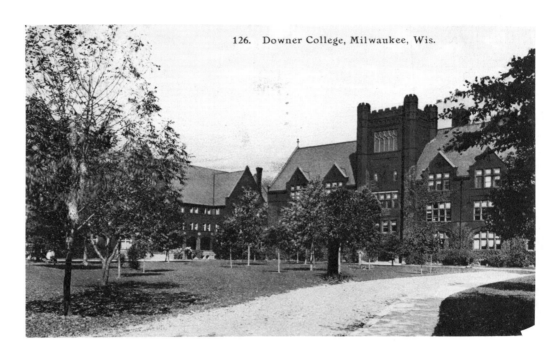

126. Downer College, Milwaukee, Wis.

Milwaukee College, first known as Milwaukee Female Seminary, was founded in 1848 by Mrs. W. L. Parsons whose husband . was the pastor of the Free Congregational Church. It was incorporated in 1851 and then became known as Milwaukee Normal Institute. In 1852 a building was erected at the corner of Milwaukee and Juneau Streets and the following year the name was changed to Milwaukee Female College; 'Female' was dropped from the name in 1876. In the meanwhile, the Baptist Church had opened a college in Fox Lake, in 1856. Its existence was in jeopardy several times before Judge Jason M. Downer of the Wisconsin Supreme Court, who died in 1883, left $80,000 to the institution, thus insuring its survival. The two organizations merged in 1895, after which President Sabin secured ten acres of land half-way between the Milwaukee River and Lake Michigan on the city's northeast side. Construction of Merril and Holton Halls began promptly, and they were occupied in September of 1899. In 1901 a third hall, a residence for students, was opened. The enrollment was 356 in 1906, close to the time this card was printed. Alexander Eschweiler was the architect of the English Gothic style facility at the corner of Downer and Hartford Avenues, and its red texture of pressed brick, sandstone, and terra-cotta with a number of interesting gargoyles blends beautifully with the surroundings. It had for years the distinction of being the only liberal arts college for women in the mid-west. The buildings were purchased in 1964 by the University of Wisconsin, and Milwaukee-Downer College eventually merged with Lawrence University of Appleton, Wisconsin.

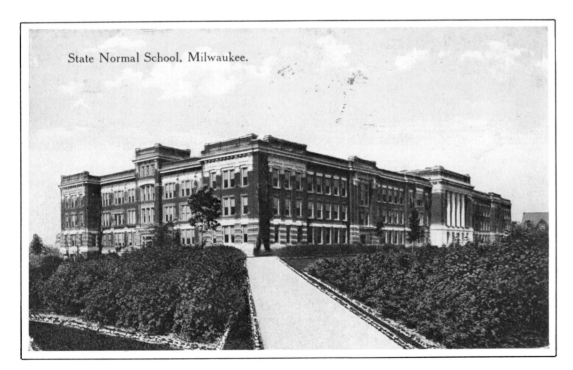

State Normal School, Milwaukee.

The State Normal School was first located on Milwaukee's west side at Eighteenth and Wells, but found a new home here in 1906 next to the Downer school, and this building was opened for classes in 1908. Note the end of one of the Downer College buildings at the extreme right of the picture. So often such institutions have been known by a variety of names. The term "Normal School" is an obsolete term applied to schools designed for preparation of teachers; in 1925 the powers-that-be decided to clarify matters by re-naming this one Wisconsin Teacher's College. Today it is an extension of the University of Wisconsin.

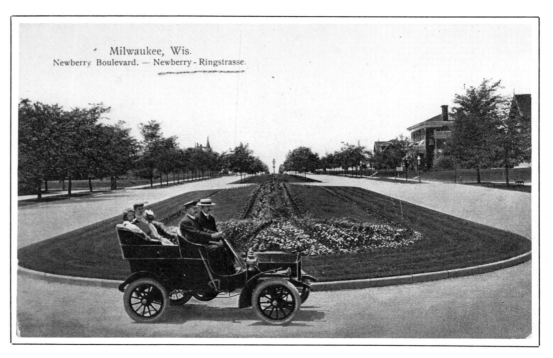

Milwaukee, Wis.
Newberry Boulevard. — Newberry - Ringstrasse.

In 1892 the Milwaukee Park Commissioners, headed by Charles Witnall, decided that all of the city parks should be connected by boulevards. Newberry Boulevard was one of the first to be established, and was to connect Riverside Park to Lake Park. Many fine houses of contrasting architectural styles abound on beautifully landscaped Newberry Boulevard, shown here as it intersects with Lake Drive. The first house erected can be seen showing barely above the trees (note its spire about an inch above the straw hat); this was the residence of B. M. Goldberg which was constructed in the French Gothic style in 1896 to designs of architects John Moller and George Ehlers. The spectacular mansion was built of tan pressed brick lavishly trimmed with carved stone and ornamental metal.

The driver of the car is wearing a cadet visored cap, suggesting that he may well have been a professional chauffeur for a wealthy family from this part of town, out for a pleasant drive in their expensive new right-hand-drive 'horseless carriage'; not a single other vehicle in sight anywhere impedes their progress. The car appears to be a Kenosha-made Rambler, built by Thomas B. Jeffery who sold out to Charles Nash. Mr. Nash had resigned in 1917 as President of General Motors to make a car with his own name. Nash merged with Hudson in 1954 to form American Motors Corporation, becoming Wisconsin's largest employer. AMC was absorbed into the Chrysler Corporation in 1987.

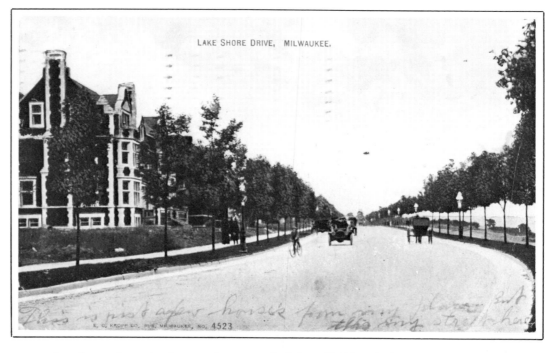

LAKE SHORE DRIVE, MILWAUKEE,

E. C. KROPP CO., PUB., MILWAUKEE, NO. 4523

On Wahl Avenue are found more imposing homes; the one at the left at #2409 is the Nunnemacher residence. Its Jacobean Revival design was produced by A. C. Eschweiler, a prominent local architect who designed many area buildings in the early part of the century.

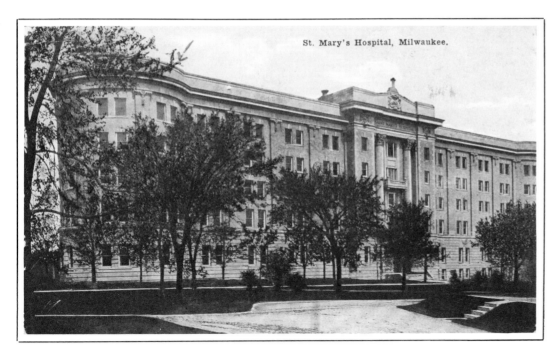

St. Mary's Hospital, Milwaukee.

St. Mary's Hospital at 2390 N. Lake Drive was designed by Richard Schmidt of Chicago and was completed in 1908. The Sisters of Charity of St. Joseph started their hospital work in Milwaukee at the corner of Oneida and Jackson Streets in 1848, and they treated many victims of the smallpox and cholera epidemics of the 1840's and 1850's. The present location was chosen in 1858, and has been the site of the hospital ever since. hnr

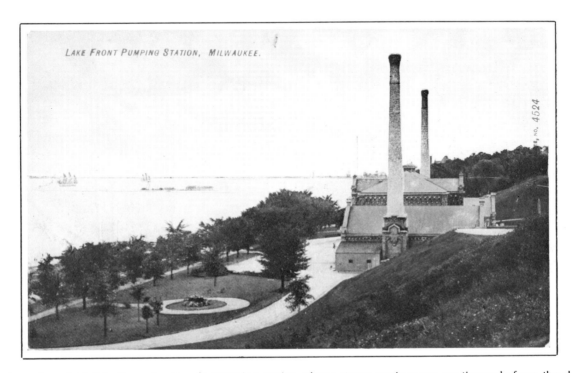

LAKE FRONT PUMPING STATION, MILWAUKEE.

Adjoining the adjacent bluff is the water tower's pumping station whose steam engines ran continuously from the day the station opened in the 1870's until they were shut down and scrapped in 1956. Most of the structure, faced with cream-colored brick, remains standing as this book is written.

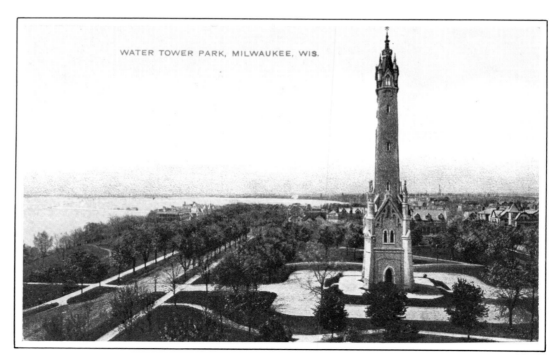

WATER TOWER PARK, MILWAUKEE, WIS.

One of the most beautiful water towers remaining in the United States is this spectacular Victorian Gothic structure, designed in 1873 by architect Charles Gombert to be constructed of Wauwatosa limestone. Its spires and ornate weathervane are still present at the time of this writing, and careful observation will reveal a carved stone ribbon indicating the date of construction. The tower is 175 feet tall, is situated on the crest of an eighty foot bluff overlooking Lake Michigan, and has been in continuous service since September 17, 1874. The masonry serves to cover a 120-foot-tall four-foot-diameter iron standpipe which helped to eliminate surges in the water pressure as the pumping engines raised the water to the twenty- one million gallon reservoir located in Kilbourn Park. The pipe is surrounded by a circular stairway. When the tower and its pumping plant seen in the previous view opened they served fifty-five miles of water mains, and by 1895 the pumping capacity had been raised to forty-six million gallons per day.

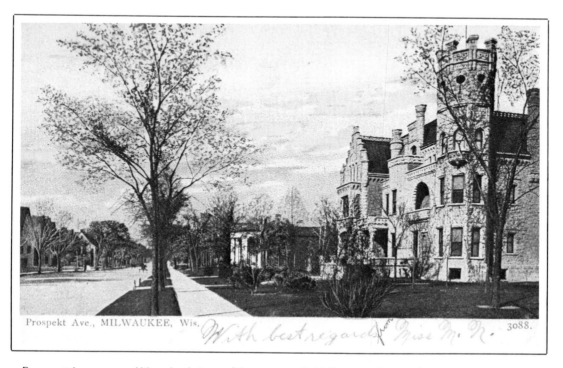

Prospekt Ave., MILWAUKEE, Wis. 3088.

Prospect Avenue was Milwaukee's turn-of-the-century Gold Coast, and many fine mansions once lined this street along the crest of the lake bluff. The commanding stone block castle- like structure at the right was the home of Mrs. D. M. Benjamin, at the southern end of the avenue. A magnificent chandelier twenty feet tall providing both gas and electric illumination hung in the stairwell, and a wide variety of rare woods were used to finish the interior. Tragically, this wonderful building fell to a wrecker's ball in 1959. While several remain, most of the great mansions of this avenue have been replaced by high-rise apartment structures. The Charles Allis Art Museum which was built in 1906 is open to the public, as is the impressive mansion housing The Wisconsin Conservatory of Music at #1584. Note the German spelling 'Prospekt' on the postcard.

All Saints Cathedral stands at 828 East Juneau, and High Episcopal services have been held here for 120 years prior to the publishing of this book. It was built in 1868 to designs of architect Edward T. Mix. Constructed of cream-colored brick and trimmed with limestone, this sturdy edifice appears quite ready to serve its parishioners for another 120 years and more after that.

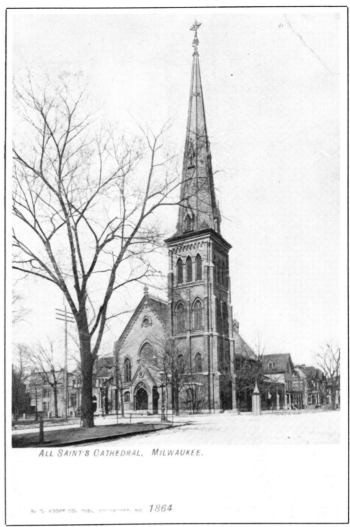

ALL SAINT'S CATHEDRAL, MILWAUKEE.

E. C. KROPP CO. PUB. MILWAUKEE, NO. 1864

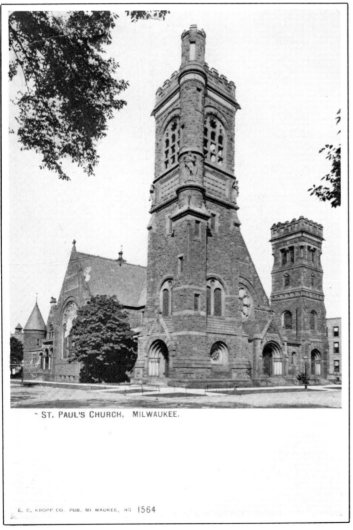

ST. PAUL'S CHURCH, MILWAUKEE.

E. C. KROPP CO. PUB. MILWAUKEE, NO. 1564

St. Paul's parish was organized in 1838, and its church at 914 E. Knapp is another design by Edward T. Mix who drew the plans for the structure in 1883-4. It is interesting to compare the designs of St. Paul's and All Saints; this one is in the massive Richardson Romanesque style, constructed with a deep red rough-faced Lake Superior sandstone. Note the carved angels on the tower. Connoisseurs of stained glass consider it worth a trip to Milwaukee just to attend a service here in order to see the glorious stained glass windows designed by the firm of Louis Comfort Tiffany. The windows were added over a thirty- to- forty-year period as funds became available to replace the original plain glass, thus representing a retrospective view of Tiffany's most creative years.

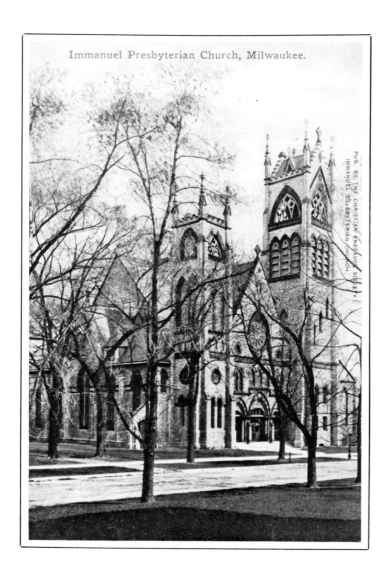

Immanuel Presbyterian Church, Milwaukee.

PUB. BY THE CHRISTIAN ENDEAVOR SOCIETY IMMANUEL PRESBYTERIAN CHURCH

Edward T. Mix was obviously a master of various architectural styles; this is his Immanuel Presbyterian Church at 1100 N. Astor which, when it was built in 1873-4, was the largest Protestant church in Wisconsin. The pipe organ's wind blower was powered by a water motor, a practice not uncommon at the time when electricity was pretty much in the future. In 1887 a fire severely damaged the structure, but fortunately the white limestone exterior survived essentially intact and only minor work had to be done to fix this beautiful Gothic Revival edifice. The pipe organ which replaced the one destroyed in the fire was acquired from the Milwaukee Exposition Center. It was built by the the well-known firm of Hook and Hastings, and had come from the Philadelphia Centennial Exposition a decade earlier. Most of those pipes from that organ are still in service. It was fortunate that this magnificent instrument was taken from the Exposition Center, for that facility burned to the ground a short fifteen years later.

Juneau Park, which is named for one of Milwaukee's pioneers, is along Prospect Avenue adjacent to the Lake Michigan waterfront. The Chicago and Northwestern Railway depot is at the south end of this urban green area. The white glazed brick and terra-cotta building at the right is the Buena Vista Flats, built in 1908-09, with its tower having been added at a later date. Today it's known by the somewhat more dignified name of The Cudahy Tower. Note the ornate ironwork on the foot bridge and the Elk monument in the distance.

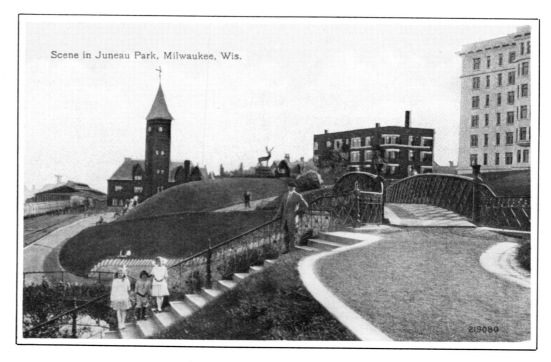

Scene in Juneau Park, Milwaukee, Wis.

219080

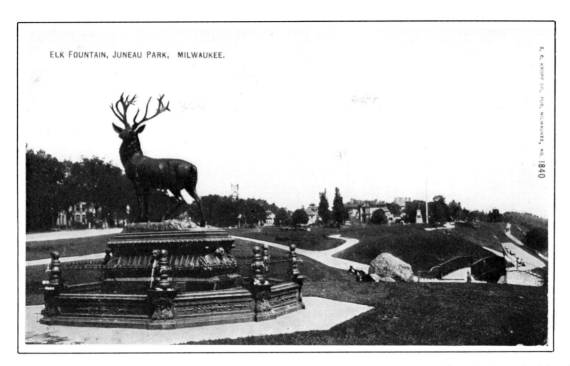

ELK FOUNTAIN, JUNEAU PARK, MILWAUKEE.

This view is looking north, with Prospect Avenue at the left. Note the absence of trees on the bluff overlooking the lake; this apparently was a deliberate effort on the part of planners to minimize any obstructions to the lovely view of this important body of water.

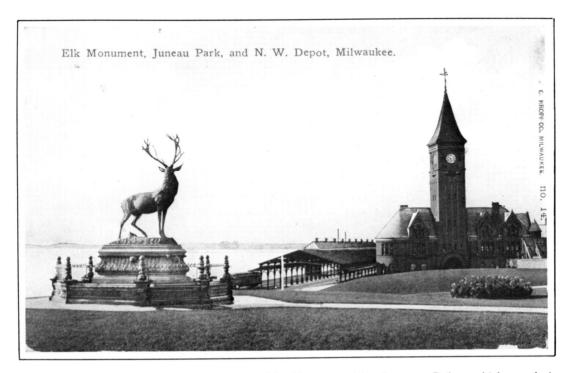

Elk Monument, Juneau Park, and N. W. Depot, Milwaukee.

Resplendent in its Victorian-age glory, the passenger depot of the Chicago and Northwestern Railway which was designed by architect Charles S. Frost assumed a commanding presence when it was constructed in 1889. Its 234-foot tower could be seen well over twenty miles out on the lake. Alas, like so many of its contemporaries all over America, it was demolished — together with its 440-foot-long train shed which had covered four tracks — in 1968, to become a vacant lot. Today, railfans shed a nostalgic tear thinking about the glory days of passenger service, and most particularly in the case of the C & NW, the 400-miles-in-400-minutes service of the name train "400" between Chicago and Minnesota's twin cities, Minneapolis and St. Paul, in the 1930's.

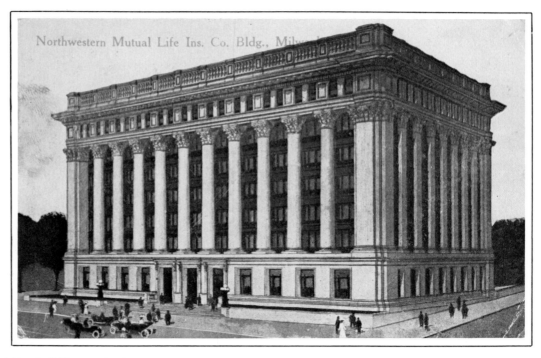

Northwestern Mutual Life Ins. Co. Bldg., Milwaukee

Today, Prospect Avenue curves west into Wisconsin Avenue, but it wasn't always that way. At the turn of the century, Prospect ended at Juneau, but in recent years street arrangements have been altered to accomodate today's traffic. And west of the river, Wisconsin Avenue was Grand Avenue; years before that it was Spring Street. In the original layout of the community streets seldom aligned, complicating the construction of bridges across the Milwaukee River.

The imposing granite structure seen here at 720 East Wisconsin Avenue was designed by the Chicago firm of Marshall Fox as the home office of the Northwestern Mutual Life Insurance Company. In 1930 an addition was completed to the rear, and yet another addition was completed in 1985. Founded in the mid-eighteen fifties, 131 years later the company was the tenth largest life insurance company, with two million policyholders and 22.6 billion dollars worth of assets.

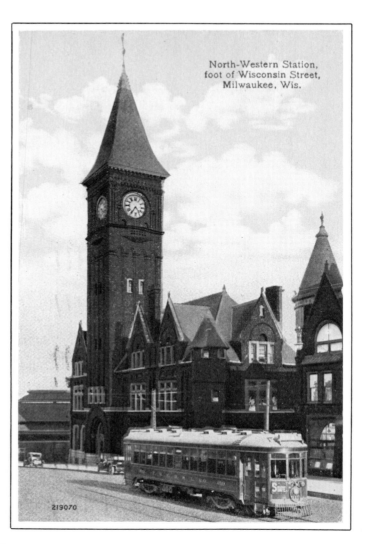

North-Western Station,
foot of Wisconsin Street,
Milwaukee, Wis.

From the front of the Northwestern Mutual home office, the Northwestern train depot presented an imposing view prior to 1968. Its towers, spires, and strange grotesque figures staring out from the base of the roof display the type of fantasy one normally associates with a fairy-tale castle in the Bavarian Alps, and not a downtown railroad station on the edge of America's dairyland. Perhaps this is precisely what architect Charles Sumner Frost had in mind when he designed the edifice for a community with such a high number of German-American residents.

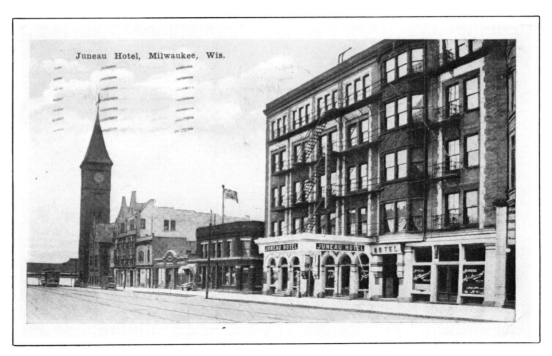

Just west from the depot is the Juneau Hotel, a convenient location for the many travelers who arrived via fine passenger accomodations on trains back around the turn of the century. Most large American cities developed following the European pattern — train stations in the middle of 'downtown,' handy to all the hotels, restaurants, and other amenities desired by salesmen and businessmen for whom inter-city travel by train was commonplace. About the time this picture was taken, clever men like the Wright brothers and Henry Ford were perfecting machines which would in a few short years forever change American travel patterns, and impact placid scenes like this in a manner that few would foresee.

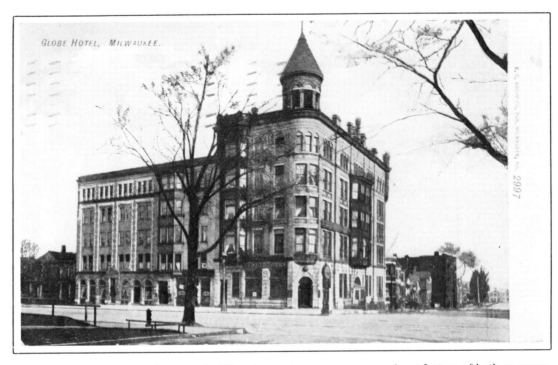

The Globe Hotel of 1890 was typical of that decade's architecture in Milwaukee, as towers were a prominent feature of both commercial structures as well as residences. Many of the small homes such as those seen here remained standing half a century later, right along-side large business buildings throughout the city's downtown areas.

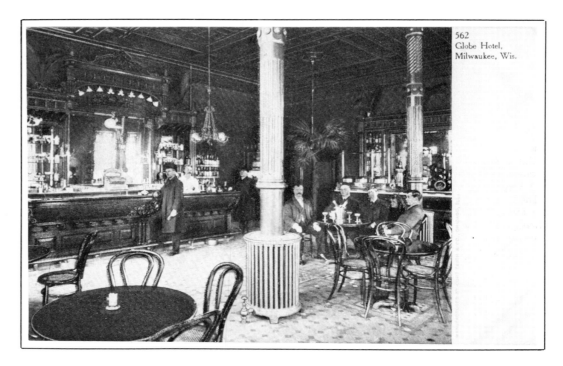

562
Globe Hotel,
Milwaukee, Wis.

This splendid saloon of the Globe Hotel was strictly for men. The pressed-metal ceiling, ornate carved bar and backbar, bent wood chairs, and brass cash register complete this 1890's scene when the price of a nice cold glass of beer was a nickel. The round radiators add a nice touch.

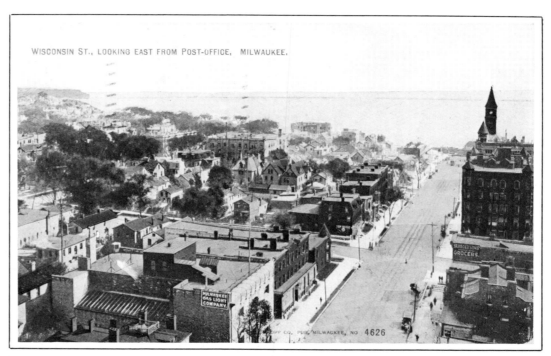

WISCONSIN ST., LOOKING EAST FROM POST-OFFICE, MILWAUKEE.

This view is from the tower of the newly-completed post office. The block in the center soon vanished to become the site of the Northwestern Mutual Life Insurance building in 1912. The small houses there dated to the 1840's and 50's, and were mainly homes of Irish immigrants; a number of the houses were moved about three blocks south to the third ward and became homes for the growing Italian community. Note the Milwaukee Gas Light Company building in the center front. Gas as a lighting source was first introduced in Milwaukee on November 12, 1852.

The Gas Light Company building in the prior scene was replaced in 1930 by this 250-foot tall one of Art Deco character with Aztec influences, as designed by architect Alexander Eschweiler. Even today, a simulated "gas flame" atop this building advises Milwaukeeans of the forthcoming weather — red for warmer, blue for change, yellow for colder, and flashing to indicate expected precipitation.

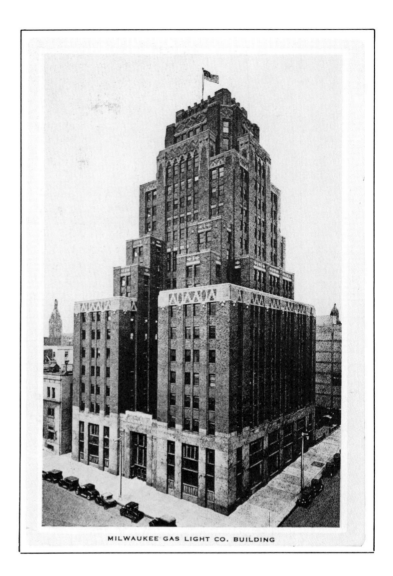

MILWAUKEE GAS LIGHT CO. BUILDING

The fine building at the lower left is the Milwaukee Post Office. Construction started in 1892, and proceeded slowly until completion in 1899, because Congress did not see fit to appropriate the required 1 1/2 million dollars to carry on the job at a faster pace. The design was by James Knox Taylor, the federal architect, who was responsible for not only the almost identical structures in St. Paul, Minnesota, and Washington, D.C., but smaller structures in lesser communities such as Ithaca, New York, and elsewhere throughout the land. At the right, at 526 E. Wisconsin, is the Northwestern National Insurance building. Constructed in 1904-6 according to designs of the Ferry and Clas architectural firm, this French Renaissance Beaux-Arts building it is one of the few in Milwaukee built in this style. All of its wrought bronze work was fabricated by Cyril Colnik. Alexander Mitchell founded this company in 1867, which prior to being housed in this fine new structure had its headquarters in the Mitchell Building on Michigan Avenue. Eighty years later, as this book is written. the view is the same.

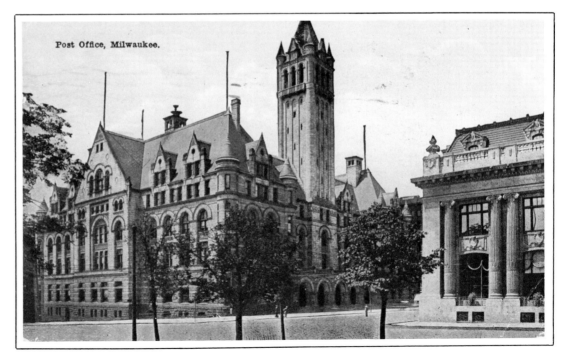

Post Office, Milwaukee.

17

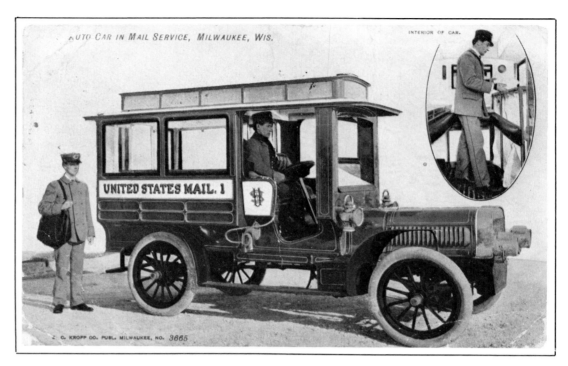

AUTO CAR IN MAIL SERVICE, MILWAUKEE, WIS.

INTERIOR OF CAR.

UNITED STATES MAIL. 1

J. C. KROPP CO. PUBL. MILWAUKEE, NO. 3665

This 'Auto car' was the first of its type for the United States Mail service in Milwaukee, and went to work in 1907. The original of this very postcard was handled in this vehicle! The original card is postmarked July 30 of that year, and was delivered to Pulaski, Wisconsin. Note the tiny space devoted to 'in-route' sorting, following the practice of the railway mail cars of the day where letters for the next town were made ready for immediate distribution once they reached that post office.

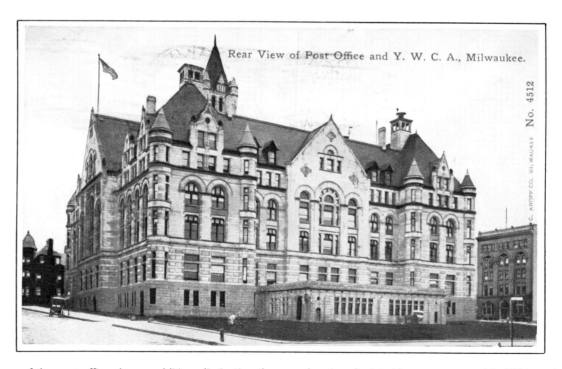

Rear View of Post Office and Y. W. C. A., Milwaukee.

No. 4512

This is the rear of the post office. A new addition eliminating the rear elevation depicted here was opened in 1931, and the architects showed great sensitivity in carefully matching the gray Maine granite and the massive Richardson-Romanesque details. Elaborate marble work and mosaics adorn the interior of the original part of the building, and of special interest are the winged gargoyles adorning the roof lines. Note the Y.W.C.A. building at the right.

The Young Women's Christian Association building was erected in 1893 and provided important service as a women's residence facility until it was demolished in 1985. The house at the right remained from the 1870's when this was a primarily a residential area. Immediately to the right of this view stood a larger 6-story Y.W.C.A. building built in 1929, but this, too was demolished — by a controlled detonation of explosives — in the summer of 1985.

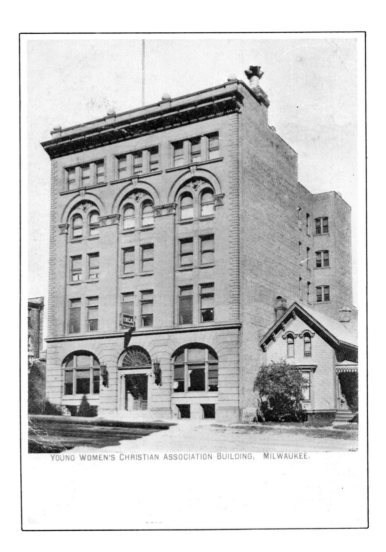

YOUNG WOMEN'S CHRISTIAN ASSOCIATION BUILDING, MILWAUKEE.

Looking west from the post office, from the corner of Wisconsin Avenue and Jefferson Street: The Goldsmith Building (built in 1892 and demolished in 1980) is at the immediate left, and the Pfister Hotel is on the right. The Goldsmith Building housed one of the largest carpet, house furnishings, and bedding outlets in the Northwest.

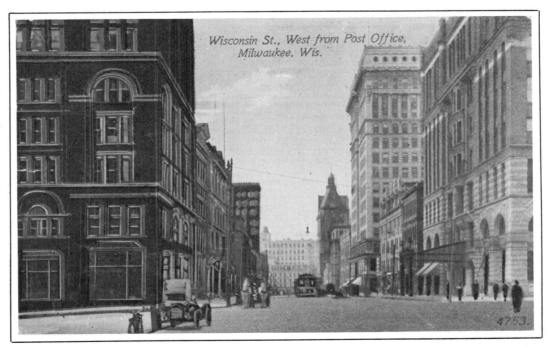

Wisconsin St., West from Post Office, Milwaukee, Wis.

4753.

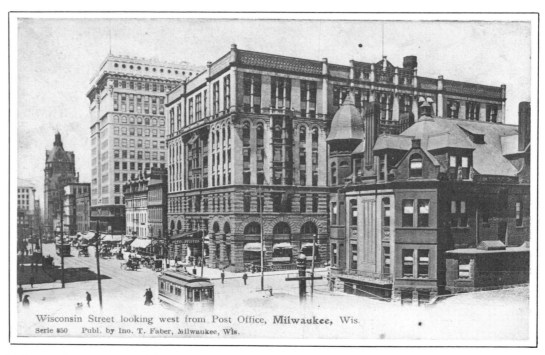

Wisconsin Street looking west from Post Office, **Milwaukee**, Wis.
Serie 850 Publ. by Ino. T. Faber, Milwaukee, Wis.

The Pfister Hotel occupies the center of this view, and at the right is the Milwaukee Club, located at 706 N. Jefferson. Edward T. Mix was the architect, and he provided a splendid blend of red brick, sandstone, and floral terra-cotta in his Queen-Anne-influenced design. This venerable organization was founded in 1882 and continues to occupy this building.

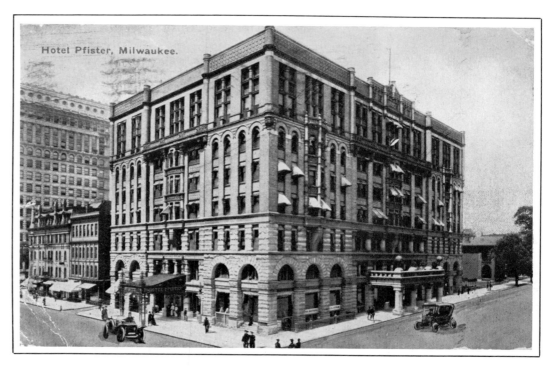

Hotel Pfister, Milwaukee.

The Hotel Pfister at 424 N. Jefferson is one of America's last surviving large downtown hotels from the Victorian era. Designed by Henry Koch in the Richardson Romanesque style in 1890-93, it is constructed of limestone and cream-colored brick, and is trimmed with buff terra-cotta. The stone portico on the right is gone, but otherwise little is changed on the exterior. A number of oil paintings remain from the large collection which adorned the interior walls in the 1890's. Note the houses at the right of the card. At the left in the view is the Pierce Block, built in 1866 in the Italianate style. The two upper floors were added around the turn of the century, and gained in this addition was a beautiful suite of rooms in Art Nouveau decor. The building still stands.

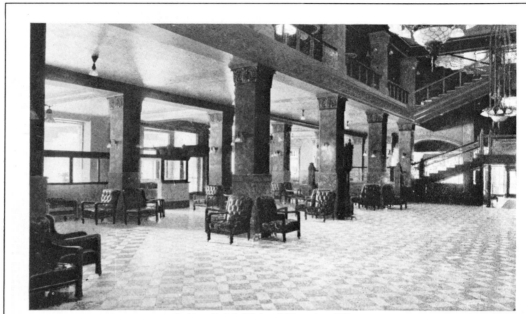

Lobby, Hotel Pfister, Milwaukee, Wis.

The visitor or guest of the Hotel Pfister is treated to this magnificent lobby, with the ornate plaster ceiling featuring the Latin word 'Salve' — meaning hail, or greetings — bidding hospitality. The wrought iron embellished staircase and the fine woodwork are a sight to behold in this day and age; lavish displays of craftsmanship were easily possible at an earlier time when skilled artisans were lucky if they got 25 cents an hour for their efforts. Today the bronze lions which once guarded the entrance stand by this staircase; they were a gift to the Pfister Hotel from T. A. Chapman who owned the department store across the street. The area at the left is now enclosed to house a restaurant. Countless celebrities from Enrico Caruso to Elvis Presley have stayed at the Pfister, as have six Presidents from William McKinley to Gerald Ford.

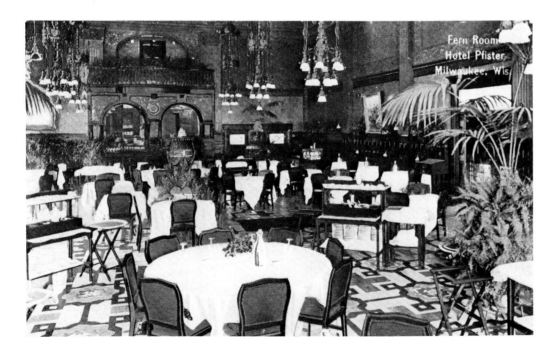

Students of Victoriana have a real treat when they stop in for lunch or dinner at the Pfister; it's fun to explore the fine architectural craftsmanship while having an exquisite meal in what for years was known as the Fern Room.

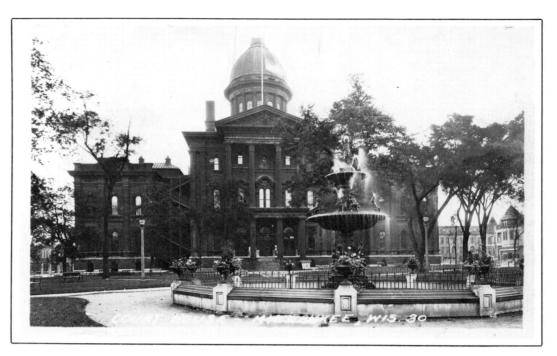

This Milwaukee Court House, built in 1872, was designed by L. A. Schmidtner and was constructed of Lake Superior brownstone. Schmidtner's real name was Baron von Kowalski, and he was the son of a royal architect in Russia. Appropriately, the structure was modeled after St. Isaac's Cathedral in Leningrad. The first court house, which this one replaced, was of Greek Revival design and was erected in 1836. A new court house located on the city's west side in 1930 sealed the fate of the lovely structure seen here. Abandoned in 1931, it remained vacant until it was demolished in 1939, and the square is now a public park.

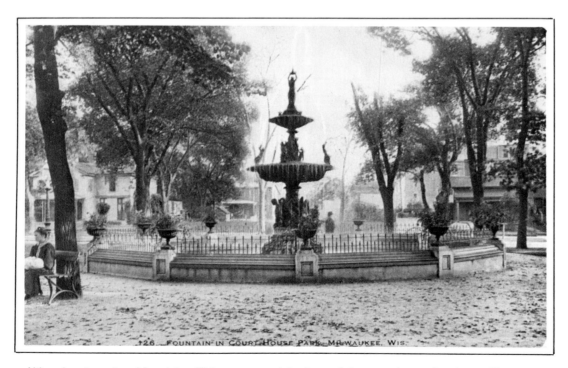

Milwaukee is a city of fountains. This one graced the lawn of the court house for almost fifty years until it was moved to the Soldier's Home in the southwestern part of the city. Established in 1868, the home was known for years as the 'National Home for Destitute Veteran Soldiers'.

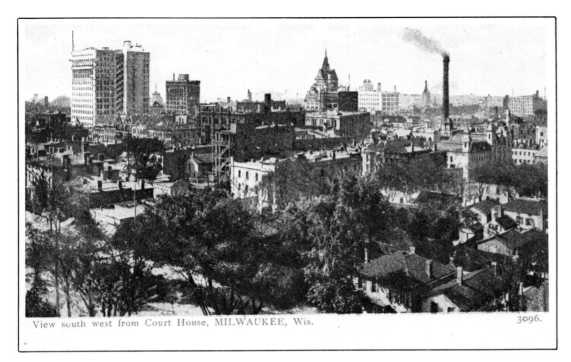

3096.

This splendid view of Milwaukee of another time was taken from the roof of the court house, and in it residences dating from the 1860's and 1870's dominate the foreground. At left center is the Matthew Keenan house constructed of cream-colored brick in 1860, designed by Edward T. Mix in the Italianate style. It still stands at 777 N. Jefferson, as do several other buildings to the right of that house. A fire a few years ago gutted the interior, but the exterior walls remained and the inside has been rebuilt. In the center is Milwaukee's first skyscraper, the Pabst Building.

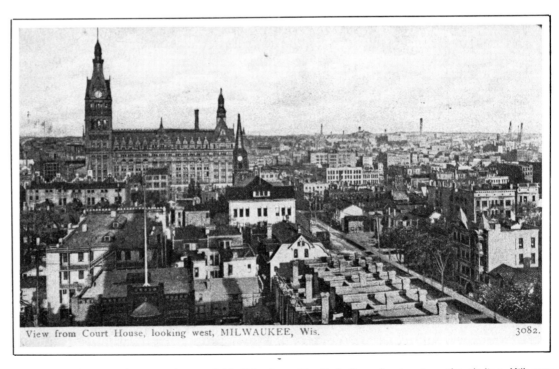

View from Court House, looking west, MILWAUKEE, Wis. 3082.

Turning to the west from the vantage point atop the court house yields this view with city hall predominant on the skyline. Kilbourn Avenue is seen at the right. The building in the foreground with the flag pole leads directly to the next postcard scene . . .

23

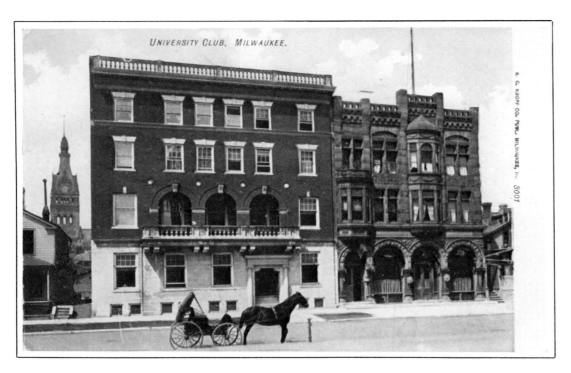

UNIVERSITY CLUB, MILWAUKEE.

. . . of Arnold & Quistorf's Saloon at the right in this view at 831 Jefferson, where a weary Milwaukee sightseer might well enjoy a brief stop to quench his thirst with a cold locally brewed beer. This Richardson Romanesque building of brown sandstone was built in 1890, and beer is still available on the premises. The University Club, organized in 1898, no longer remains in the featured structure on this card, for in 1926 the club engaged the nationally known architect John Russell Pope to design a new building at 924 E. Wells. Pope designed the Jefferson Memorial as well as the National Gallery of Art, both in the nation's capital, and he supervised the reconstruction of the French Gothic Chapel of St. Martin de Sayssuel of France, where Joan of Arc is said to have worshipped.

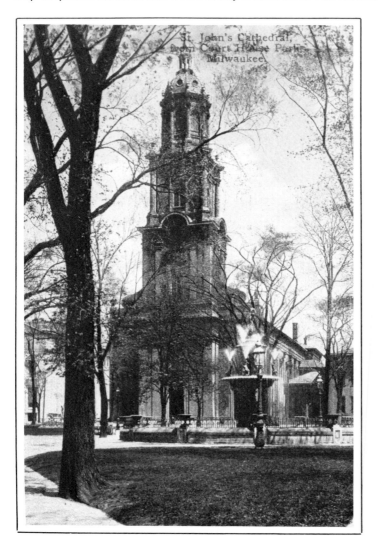

St. John's Cathedral, from Court House Park, Milwaukee

Across Court House square to the east the beautiful 210-foot tower of St. John's Cathedral dominates the scene. Designed by Victor Schulte, the Cathedral was built in 1847 with a tower only half as tall as it is today as seen in this view; in 1892 architects Ferry and Clas designed the upper portion. Close examination of the building reveals that the cream-colored bricks, now blackened by dirt and soot, differ slightly in the original structure from the newer section of the tower and a later addition at the ground level. To make the match as close as possible, materials were reclaimed from old 1840-50's houses of the area.

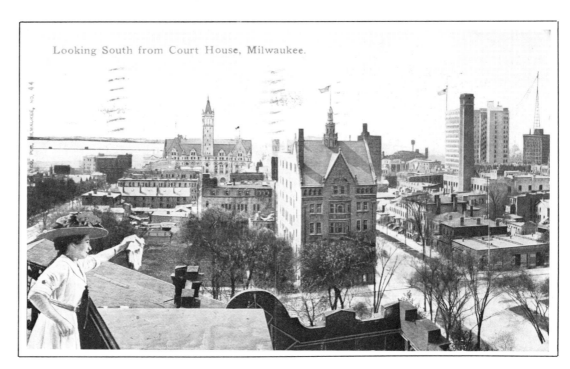

Looking South from Court House, Milwaukee.

Still another view from the 174-foot-tall Court House, this time looking southward. Note the post office building in the distance and the lake beyond it. Who is the lady in the hat? Is she waving her handkerchief to signal someone below on the street? Did she buy her hat at T. A. Chapman? None of this information is provided on the original card, and we can only assume that she is the photographer's wife or girl friend shaking out her hankie after wiping off the camera lens. The new building which replaced it in 1929 was of a neo-classic character and the famed architect Frank Lloyd Wright, who was an unsuccessful contender to design it, referred to the finished product of his competition as "a million dollar rock pile".

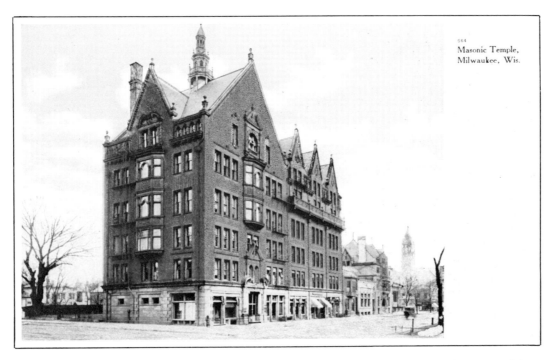

564
Masonic Temple,
Milwaukee, Wis.

The Masonic Temple built in 1895 at the southeast corner of Jefferson and Wells is the building at the center of the previous postcard. It was demolished in 1964, but several sections of carved stone ornamental work from it have been preserved, set in the lobby wall of the building currently occupying the site. The lodge used portions of the fifth and sixth floor; the first three floors consisted of offices and small halls, and there were banquet halls in the building as well.

25

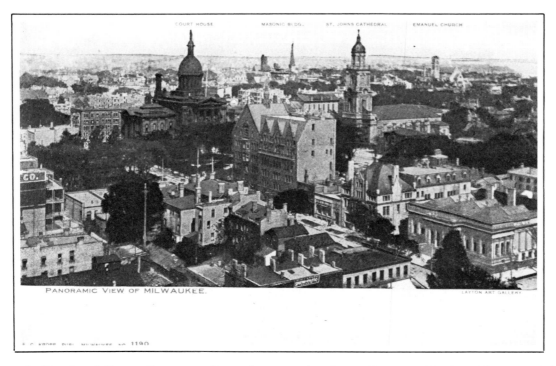

In this view Jefferson Street cuts diagonally across the picture. Compare this view with some of the previous ones; the Masonic Temple, Matthew Keenan's house, and the Court House are all seen in it.

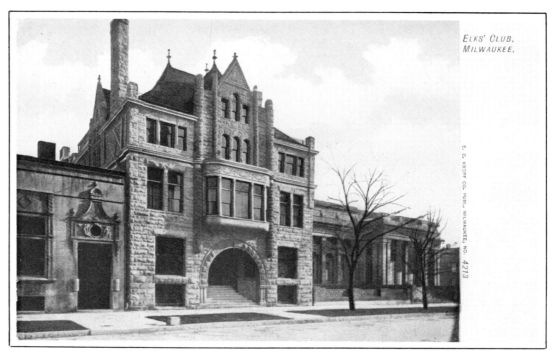

At the center right of the previous view, on the east side of the street, is the clubhouse of the Fraternal Order of Elks, and to its right is the Layton Art Gallery. This was the headquarters for Elks Lodge #46 from the mid 1880's to 1927 when they moved to their new home east of the Northwestern Mutual Insurance offices. In 1928 this became the Moose Club building, and later the Phoenix Club before it was demolished in 1957.

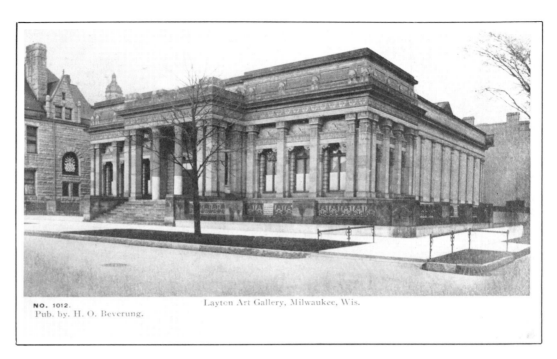

NO. 1012.
Pub. by. H. O. Beverung.
Layton Art Gallery, Milwaukee, Wis.

The architectural style of the Layton Art Gallery at 758 N. Jefferson was quite unusual for Milwaukee. Its Egyptian Revival style was developed by the architectural team of Edward T. Mix and G. A. Audsley. Built of Indiana limestone and trimmed with elaborate ironwork, it was completed in 1888 and demolished in 1958 for a life span of just 70 years. Note the fine stained glass window of the Elks' Club to the left.

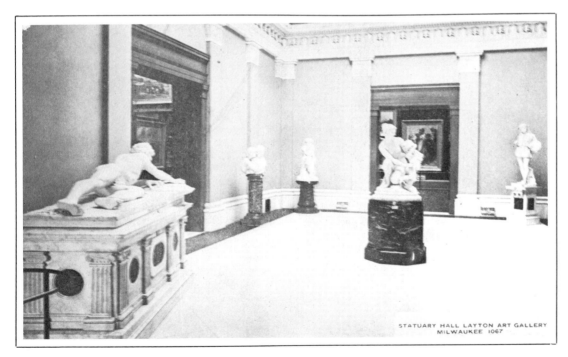

STATUARY HALL LAYTON ART GALLERY
MILWAUKEE 1067

The 'Fallen Warrior' at the left in the statuary hall of the Layton Art Gallery now resides in the Milwaukee County Court House at Eighth and Kilbourn Avenues. When the gallery came down, a vast treasure of architectural details such as frames and marble pedestals were destroyed.

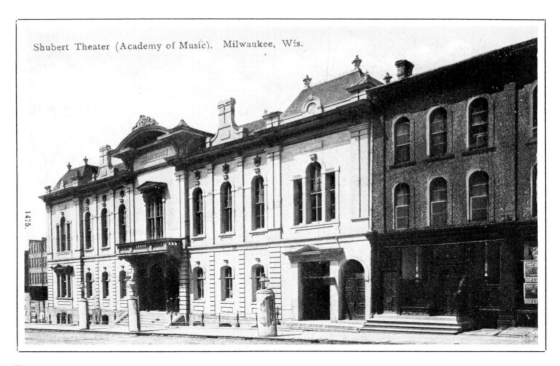

Shubert Theater (Academy of Music). Milwaukee, Wis.

The Shubert Theatre, also known as the Academy of Music, opened in 1865 at 375-389 N. Milwaukee Street and for years played an important part in Milwaukee's cultural life. This view is particularly interesting as the McGeoch Building which was built in 1894 (at 322 E. Michigan) immediately adjoining at the left of the picture, is not seen here — suggesting that the photo was at least ten years old before it was printed as a postcard. Part of the building at the right remains, although the left half of it was demolished at some time in the past.

Proceeding northward one sees on the southwest corner of Milwaukee and Wisconsin Avenues the Birchard Furniture block which was constructed in 1867; an additional floor was added in the late 1890's. This establishment was one of the earliest furniture manufacturing companies in the state of Wisconsin. The prominent building here, however, is the 200-foot-tall white brick and glazed terra-cotta building designed in 1901 by H. C. Koch for railroad magnate Daniel Wells, who was one of the richest men in Milwaukee. The first two floors are decorated on the exterior with sheet copper and cast bronze ornaments, and three very fine mosaic domes in the vestibule and white marble in the lobby create an imposing entrance to the visitor. Today the top floors are missing the terra cotta ornamental work which formerly crowned this building's glory. The Wells building occupies the site of the old Federal Court and Post Office building erected in 1856. Aside from the fact that horseless carriages have replaced the equine-drawn vehicles of that earlier time, this view is essentially the same today.

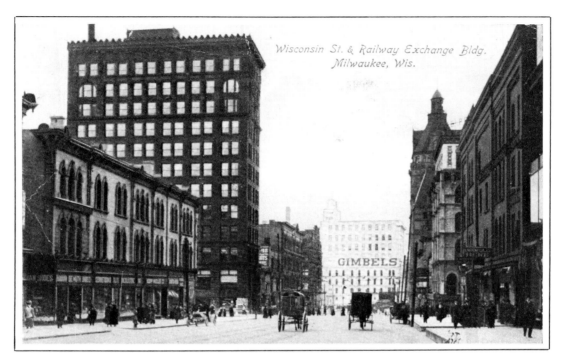

The view looking west on Wisconsin Avenue between Milwaukee and Broadway: Follansbee's block, dating from the 1860's, is on the left and the Spencerian Business College, which opened in 1863, is on the right.

The Edmund Gram Piano House on Milwaukee Street was the place to purchase everything musical — a fine Steinway grand piano for those who wished to acquire the very finest for the concert hall or the home, a pedal-pumped player piano for home en-

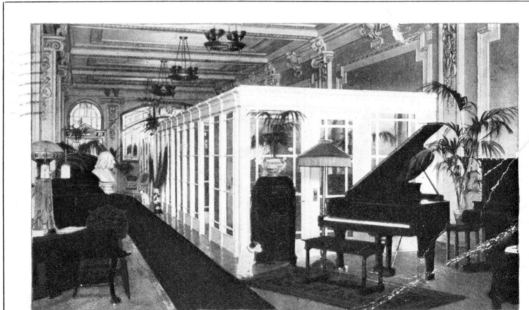

Victrola Booths, Main Floor, Edmund Gram Piano House, 414-416 Milwaukee St., Milwaukee.

tertainment or (as their manufacturers suggested, for the proper musical elucidation of the young), or, if you happened to own a saloon or billiard parlor, a dandy coin-operated automatic piano which provided profit-making entertainment from the customers' own nickels as they sipped their Milwaukee-made brews. Note the Victor dog "Nipper" on the floor, and the Victrola Model 18 which was sold only during the winter of 1915-16, thus dating this card with considerable accuracy. This was a time when such stores had 'listening rooms' where the prospective purchaser of a phonograph record could try it. This store called them 'Victrola Booths' as was proper for a Victor agency, and they're in the white enclosure. The detailed plasterwork and furnishings are a forgotten elegance in today's type of merchandising. Prior to 1912 the firm had been at 207 Grand Avenue on the west side of the river. In addition to Steinway, the firm sold Everett, Weber, and Steck pianos as well as the Pianolas manufactured by the Aeolian Corporation, together with Link automatic pianos (the same Link associated with the flight simulation industry) and RCA Radiolas.

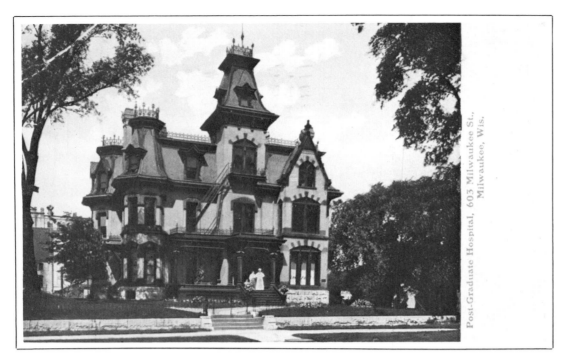

In our turn-of-the century downtown tour, business establishments on Milwaukee Street give way to fine homes as Juneau Street nears. This home was built for David Ferguson in the 1870's, but by the time this card was printed it had already become the Post Graduate Hospital. Directly to the left past the trees can be seen the Blatz Brewery on Broadway. The house is gone, and the brewery stood vacant awaiting the wrecker's ball when it was granted a stay of execution; it has been converted into condominiums. With its cream-colored brick cleaned and the exterior restored, it stands to serve future generations.

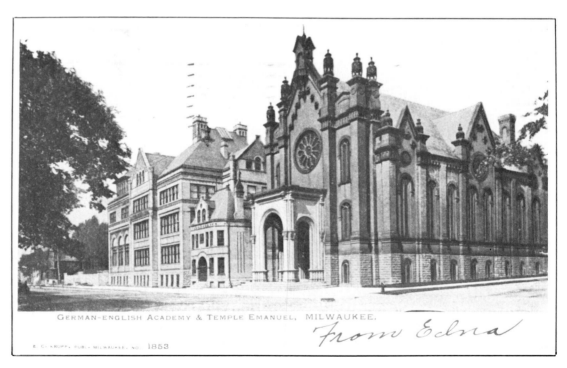

GERMAN-ENGLISH ACADEMY & TEMPLE EMANUEL, MILWAUKEE.

E. C. KRUPP, PUBL., MILWAUKEE, NO. 1853

From Edna

Peter Engelmann, founder of the German-English Academy, came to America from Heidelberg, Germany, which he was forced to leave due to his involvement in the revolution of 1848. Originally started on the West side in 1851, this institution moved shortly thereafter (1853) to a new building on Broadway, even though the structure was not completed until 1856. In 1875 one of the first kindergartens in the city was opened. In 1890, Mrs. Elizabeth Pfister and Mrs. Louisa Vogel donated the present site and the building seen here was opened in 1891. Designed by Crane & Barkhausen, it features cream-colored brick trimmed with terra-cotta ornamentation (a very popular combination in Milwaukee). Classes taught in German as well as English ranged all the way from kindergarten through scientific laboratory work at college levels. The North American Gymnastic Union merged with the German-English Academy and built an adjoining model gymnasium. Today the exterior of the structure is almost like new, although the building no longer houses the academy. Temple Emanu-El at the right, no longer standing, was built in 1872.

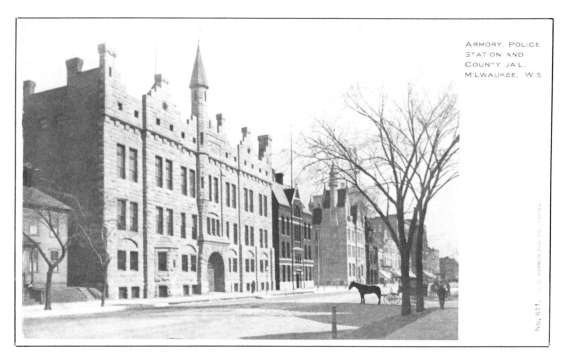

Crossing State Street (formerly known as Martin), heading south, years ago one would have seen this stone fortress at 814 N. Broadway. Constructed in 1885, the Armory housed housed The Light Horse Squadron as one of its functions; the squadron was formed in 1880 to perform escort duty for General and former President Ulysses S. Grant when he visited Wisconsin during a reunion of Civil War veterans. The Armory eventually became the headquarters of the Wisconsin National Guard, and finally served as the auxiliary building for the police department next door before it was demolished. Further down the street is an elegant castle-like structure which was the county jail. Note at the very left an original 1840's house. Sadly, everything in this picture is but a memory.

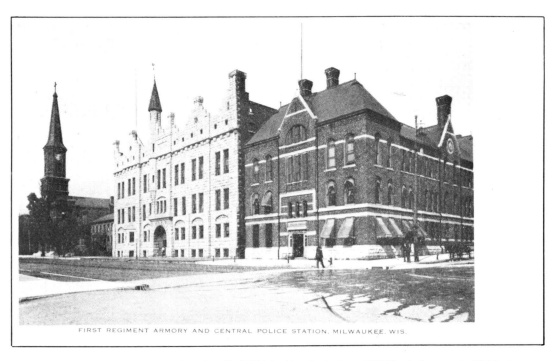

In the opposite direction one old landmark still stands; — the church called Old St. Mary's, built at 836 North Avenue in 1846, the year Milwaukee became a city. The tower was an 1867 addition. This was the city's first Roman Catholic church. Upon entering, one is struck by the glow through the magnificent stained glass windows, enhanced by the fine painting over the altar. This work of art was a gift of King Ludwig of Bavaria, given to Milwaukee even before Germany became a unified country.

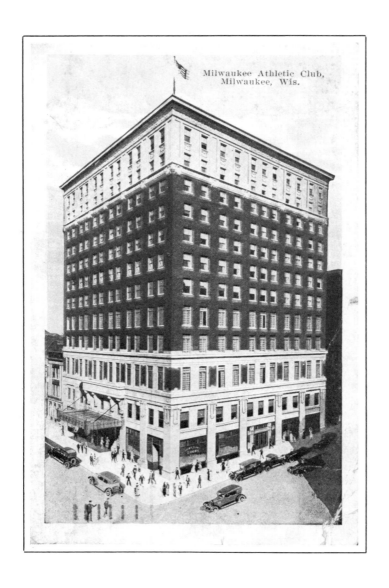

The Milwaukee Athletic Club, designed by Armand Koch in 1917, is located at 758 N. Broadway and appears much the same as seen here.

Below is the newest view in this book. All too often when remodeling takes place the result is a dreadful hodgepodge, but here's a case where a specific style was carried out in superb fashion. The Milwaukee Athletic Club's cocktail room is a remarkable example of the modern 1930's Art Deco style, and characterizes well this new design form which gained a great deal of publicity due to the 1933 and 1934 Chicago World's Fair, held just 85 miles to the south as measured between Milwaukee Railroad stations. The style gained its name from the 1925 Exposition des Arts Decoratifs in Paris, which produced the Zigzag Moderne.

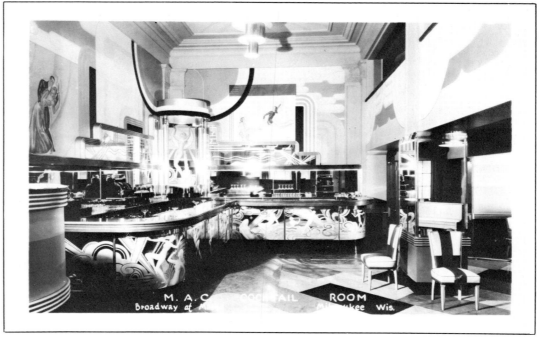

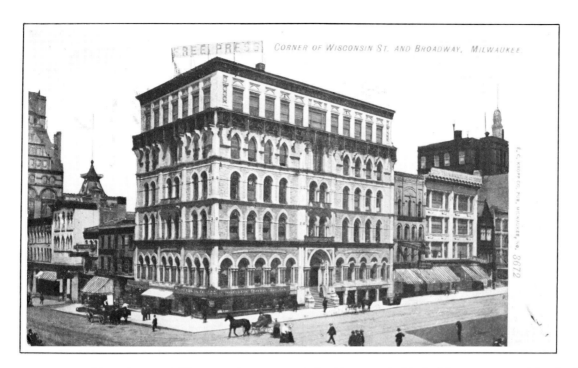

At the northwest corner of Broadway and Wisconsin Avenue stood this Victorian Gothic building constructed for the Northwestern Mutual Life Insurance Company in 1870; it served as their headquarters until they moved down the street in 1885. The rather stark fifth floor was added around the turn of the century. This building was one of the first in the city to be equipped with elevators. The story is told about a clever Milwaukeean named Christopher Latham Sholes who had invented the first practical typewriter and brought his new machine to the company for a demonstration. The president of the insurance company was apparently unimpressed, for he did not like this 'new fangled thing' and told Sholes to leave. By 1940 only two floors of the building remained and by the mid 1960's the building vanished from the street.

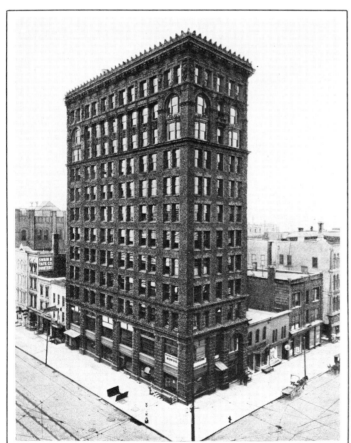

Milwaukee, Wis.
The Railway Exchange Building. — Das Eisenbahn-Börse-Gebäude.

On the southwest corner of Broadway and Wisconsin stands the Railway Exchange Building designed in 1901 by Chicago architect William Jenny. Another eighty-foot-wide section was to be built to the right, but construction never materialized. Much beautiful terra-cotta can be found complementing the deep red brick of this fine structure. Fortunately, the only part missing from the fine turn-of-the- century office building is the cornice.

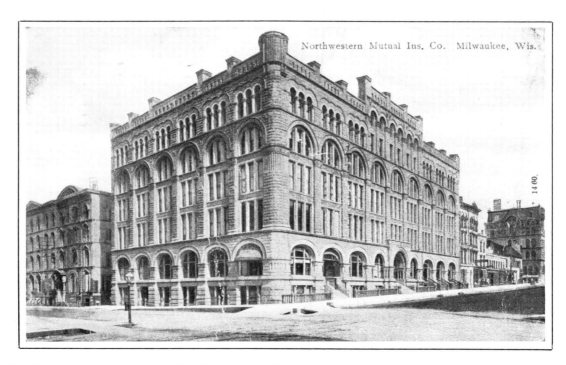

Northwestern Mutual Ins. Co. Milwaukee, Wis.

The second building to be constructed for the Northwestern Mutual Life Insurance Company is located on the northwest corner of Michigan and Broadway. Designed by S. S. Beman of Chicago in 1885, who also designed the company-owned town of Pullman, Illinois, it was built on the site of the Newhall House hotel. The first two floors are constructed of granite with the remaining floors of Bedford limestone. Inside, beautiful tile floors remain, and a splendid skylight provides natural illumination for the iron and copper staircase. All of the copperwork was once painted black, allegedly to make it a less likely candidate for removal for wartime metal salvage drives. Recently restored to its original splendor by a farsighted owner, the building is an outstanding example of the inherent beauty of Victorian craftsmanship being preserved to add pleasure to our and future generations.

Constructed of limestone in 1856-57, the building in the Italian Renaissance style to the left at 210 E. Michigan houses the Bank of Milwaukee. Soldiers stood guard here to prevent the building from being burned in the bank riots of 1861. This was not its only close call with fire, for on January 10, 1883, fire broke out in the Newhall Hotel next door. Today, standing in the alley between the two buildings, one can well imagine the screams of terror as ladders were stretched from the hotel to the bank building and guests scrambled to safety. Seventy one lives were lost in this dreadful holocaust, and walls blackened by time and smoke bear witness to this dreadful event. The building was designed by architects William Boyington and Edward T. Mix; the latter was a young man from Chicago who had just settled in Milwaukee, joining the older Boyington for a short time. This early project helped launch Mix's remarkable, albeit brief, career. Some of the carved stone ornamental work was removed in the 1960's to "modernize" the structure; apparently the folly of this was recognized before all was lost, and only about half of the fine stone carvings are gone.

To the right in the background can be seen the original building occupied by Northwestern. Note the mansard roof and delicate roof cresting; they were chopped off and a very plain and ordinary additional floor was added, as seen in the picture two cards back. The Railway Exchange Building was not built yet, indicating that the picture in this card dates from earlier than 1901.

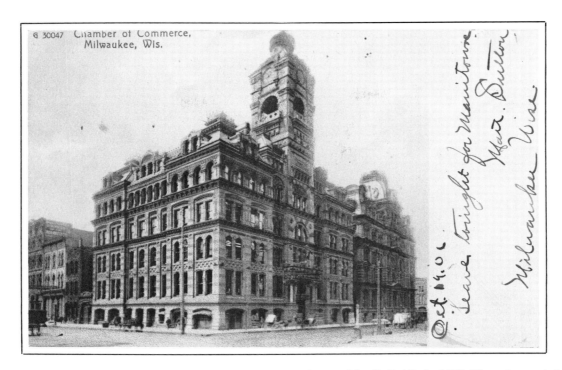

This outstanding building across the street at 225 E. Michigan was designed by E. T. Mix in 1879-80, and served the Chamber of Commerce and the Milwaukee Grain Exchange until 1935. On its gray Ohio sandstone exterior can be found the Seal of Wisconsin, a steamboat, and a bull and bear carved in stone. On top of the entrance flanked by granite pillars once stood a statue of Lady Commerce, but she left for greener pastures and can now be found in a public park at approximately 38th and Forest Home Avenue on Milwaukee's south side. The interior of the building was remodeled and modernized over the years, but in the early 1980's false ceilings were stripped away, revealing one of the finest interior spaces in all America! Today this four-story open interior is breathtaking to behold, with gloriously painted and stenciled walls, etched and stained glass windows, gleaming brass hardware, magnificent oak woodwork, and a fabulous parquet floor - each of these features rivalling the other in unsurpassed beauty. Comparing pictures of this room from 1880 and today reveals virtually no difference.

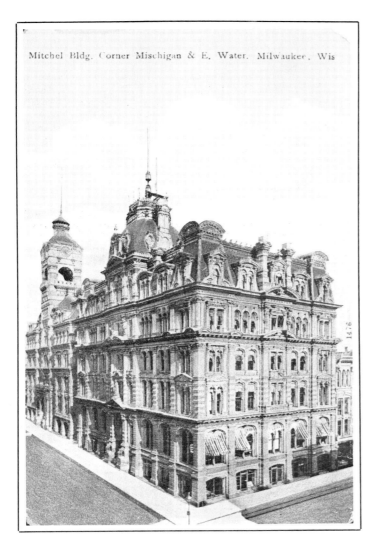

Mitchel Bldg. Corner Mischigan & E. Water. Milwaukee, Wis

The Mitchell Building just to the west is probably the finest Victorian commercial structure standing in the United States; more ornamental work can be found on these two adjacent buildings than on any other block in America. Amazingly, it is possible today in the late 20th century to take the same picture as this view from around 1900. Designed in 1876 for Alexander Mitchell by Edward Townsend Mix in the Second French Empire style, it orignally served as a bank building. Winged horses and caryatid figures as well as other ornamental features adorn this Victorian fantasy, and gold-leaf griffins still guard the entrance. Mix was one of America's greatest Victorian architects and a master of this school of design.

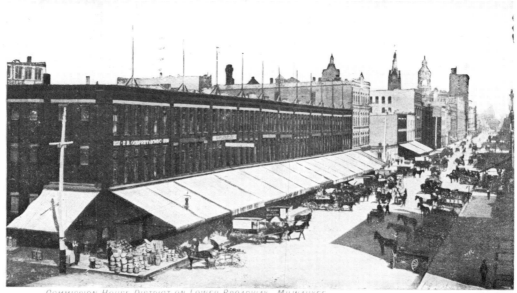

COMMISSION HOUSE DISTRICT ON LOWER BROADWAY, MILWAUKEE.

E. C. KROPP. PUBL. MILWAUKEE. NO. 1566

Going south on Broadway today one encounters an expressway slicing across the path, and nearby is Buffalo Street and the famed area known as Commission Row, where fruit and vegetable merchants buy and sell their produce. Some of the buildings are gone, but many remain complete with their corrugated metal canopies as seen here in this early view — the main difference being that trucks have replaced the horses and their wagons. A careful examination of the pavement might reveal a few old granite paving blocks through the asphalt of this hundred-year-old commercial district. Many fine 1890 vintage warehouses still stand along this street, the Buffalo Block being one of the better-known.

Just west on Buffalo Street was East Water Street, the oldest street in Milwaukee; the present Plankinton Street west of the river used to be West Water Street, but today, Milwaukee has only one Water Street. Without this minor clarification endless confusion would result from trying to compare the street names in some of these picture captions with the names seen on any turn-of-the-century map. Photogaphed from the Buffalo Street bridge, this view shows on the right the block of red pressed brick designed by Schnetzky & Liebert in 1893 for J. P. Kissinger. A dealer in wines and liquors, he had estab-

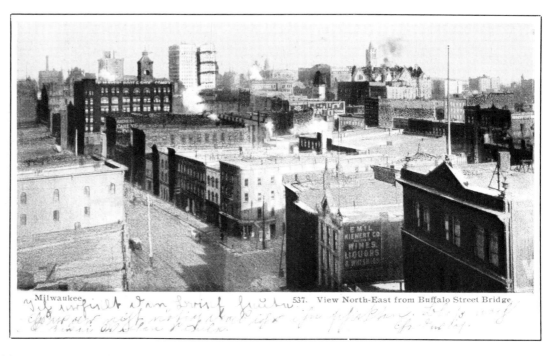

537. View North-East from Buffalo Street Bridge

lished the business in 1856 and his name can still be found on the building's facade. In approximately the center of the scene at 402 N. Water was the Cross Keys Hotel, built in 1853. When it burned in 1980 it was one of the oldest remaining hostleries. It achieved a certain amount of fame because Abraham Lincoln once spoke there. The building was not without its problems; because it was constructed on a swampy area it tended to subside below the street level, and its fourth floor had been removed around the turn of the century after a serious fire. Immediately to the left of where this hotel stood the present expressway runs east and west. The dark building at the upper left is the Button Block at 500 N. Water. Constructed in 1892 of red pressed brick trimmed with red sandstone, it housed the largest wholesale drug business in the midwest. Today the building features a fashionable nightclub, and its tower cuts a stunning silhouette against the simple lines of the expressway.

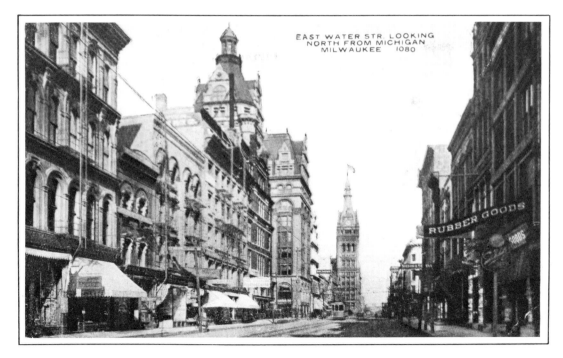

From a vantage point at the intersection of Michigan and Water Streets the City Hall stands prominently in the background. The Bank of Milwaukee building is seen at the right. Several of the buildings at the left were replaced by the Marine Bank in 1959, but several on the right of this view remain in place, including the recently renovated Iron Block Building.

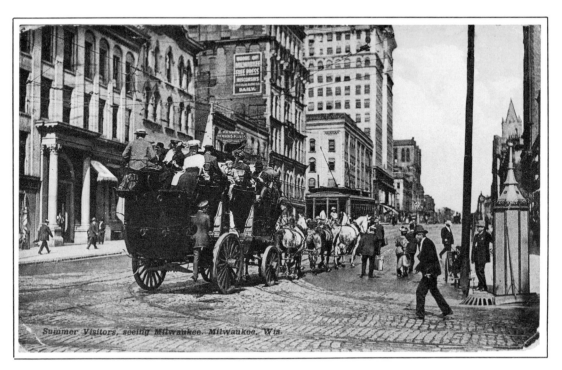

In this great view of Old Milwaukee we get a glimpse of the way tourists used to see the city. The intersection is at Wisconsin Street and Water, the latter previously having been East Water. The Northwestern Insurance building is at the center, and is at the turn of the century when this picture was made occupied by the Free Press. The taller building down the street is the newly completed Wells Building, and the Post Office tower is partially visible at the right. Note the policeman's call booth on the corner; as the present century wore on these were replaced by square cast iron boxes.

Water Street is Milwaukee's oldest. Cobblestones were initially limestone, and by the 1850's a pinkish white granite became popular. Later stones were of an almost black color, with most streets of the 1880's being paved with a purplish red granite variety. The stones were quarried and cut in central Wisconsin and many of them, all of which were cut by hand, weighed as much as thirty pounds.

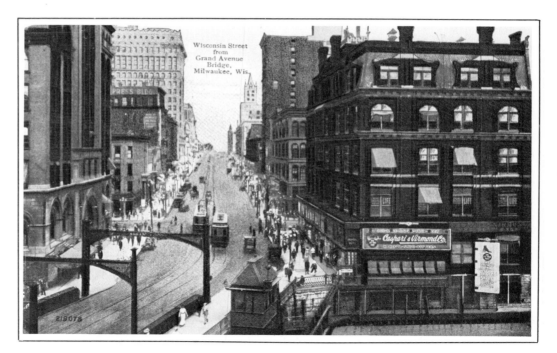

The Wisconsin Avenue bridge, built in 1906 to span the Milwaukee River, is at the lower left, and the tower of the Post Office is visible in the distance. Note that the card refers to the 'Grand Avenue Bridge,' obviously from a time prior to the re-naming of Grand Avenue to Wisconsin Avenue, apparently done to minimize confusion. At the right is the Mack Building; it was demolished in 1959 to make way for the Marine Bank. At the southeast corner of Water and Wisconsin is the Excelsior Block, built in 1860, after which it quickly became known as the Iron Block because of its cast-iron construction. It has the distinction of being Milwaukee's only remaining cast iron building, and has an especially interesting construction history. The first facade shipped from New York City where it was fabricated rests on the bottom of Lake Michigan, as the boat sank en route near Whitefish Bay. Architect George H. Johnson not only had to contend with a lost building front, but he also had to devise a foundation that would support the enormous weight of the building on swampy ground that wasn't anxious to hold it. He designed a foundation of inverted arches crowned by pilasters, and it is said that designers from all over America came to marvel at his achievement; only two other buildings prior to the time had featured this concept. An almost identical structure exists in New York City.

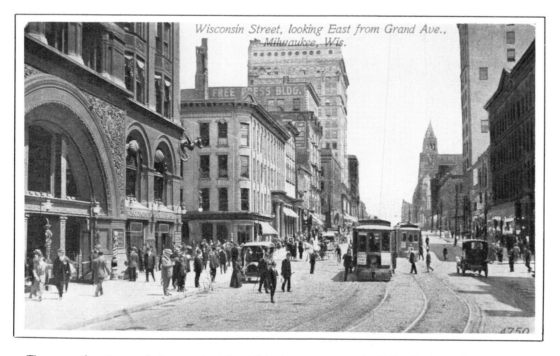

The magnificent carved stone arch at the left is the entrance to the Pabst Building. For ten years prior to its disappearance, this nifty iron dragon was featured on its corner, suspending a gas light from his mouth. The next building to the east is Kirby's Block, also known as Jeweler's Corner, and it gained fame as having one of Milwaukee's earliest large pieces of plate glass installed — five feet by four feet. People came long distances to view what for its time was an enormous piece of exterior glass. The Milwaukee Public Library first served the public from this building. Today the Banker's Building, built in 1929, occupies this spot at 208 E. Wisconsin Avenue.

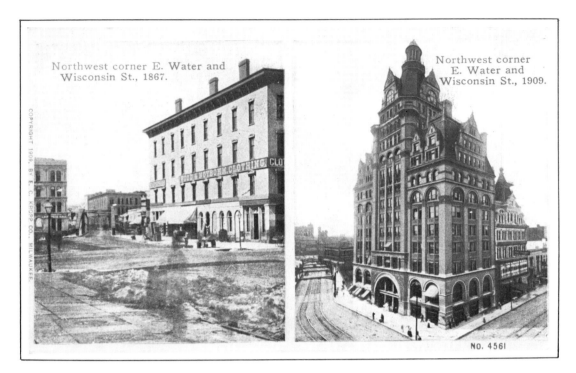

Northwest corner E. Water and Wisconsin St., 1867.

Northwest corner E. Water and Wisconsin St., 1909.

NO. 4561

This interesting card depicts two eras in time on this historic corner. The first log cabin was erected here in 1800 by Antoine LeClaire, and then Solomon Juneau built a stockade containing his residence and general store on the same site in 1835. This site was eventually cleared, and the Ludington Block seen at left was built in 1851. Then in 1891-2, S. S. Beman of Chicago designed this great 235-foot-tall skyscraper for Frederick Pabst of Pabst Brewing Company fame, and it was built at a cost of $350,000. With its Flemish Romanesque details richly detailed with terra cotta, it was a sight for every tourist to see. The grand staircase had designs of intricately cast iron which were copper plated, and even the hardware was made especially for the building; each doorknob had the Pabst logo cast in it. Those fortunate enough to be able to get to the top of the building were rewarded with a great view of the entire city, as seen in the next card. The tower was removed in 1948, and the rest of the upper details and gables were 'modernized' off of the building, and finally in 1980 the site reverted to a grassy plot, perhaps much as LeClaire had found it 180 years earlier.

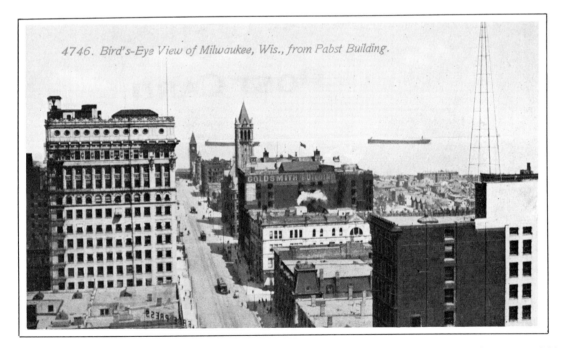

4746. Bird's-Eye View of Milwaukee, Wis., from Pabst Building.

Gazing down from the Pabst Building tower the viewer sees the Wells Building, the Chicago and Northwestern Railway Depot, the Goldsmith Building (name painted on the side), the Chapman Department Store designed by E. T. Mix in 1884 (in front of the Goldsmith Building) and the Railway Exchange Building, with its telegraph wireless tower.

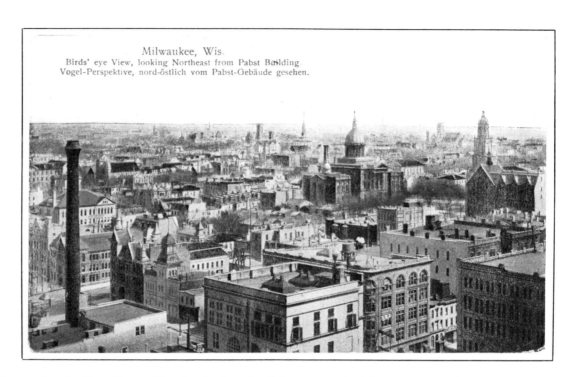

Milwaukee, Wis.
Birds' eye View, looking Northeast from Pabst Building.
Vogel-Perspektive, nord-östlich vom Pabst-Gebäude gesehen.

This bird's eye view (or Vogel-Perspektive, for the benefit of German readers) looks northeast from the top of the Pabst Building. Prominent buildings are the courthouse, the jail, the fire station next door, the tower of St. John's, the Masonic Temple and, directly in front of it at 302 E. Mason Street, the Colby Abbot Block built in 1881. It and St. John's are the only structures remaining. One of Milwaukee's fine German restaurants, Karl Ratzsch's, is in the building; evening diners are entertained by a string trio, for live music has traditionally been a part of the fare.

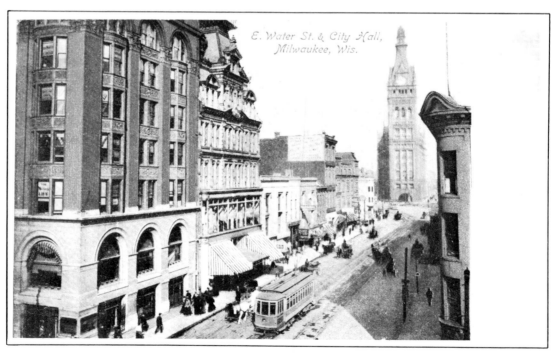

E. Water St. & City Hall,
Milwaukee, Wis.

Looking from the upper floors of the Iron Block down North Water Street, the Pabst building is at the immediate left, with its iron dragon already having disappeared. Right behind the streetcar is Waldheim's Department Store. The buildings further down the street would soon disappear to make room for the First National Bank Building. Note the City Hall in the distance.

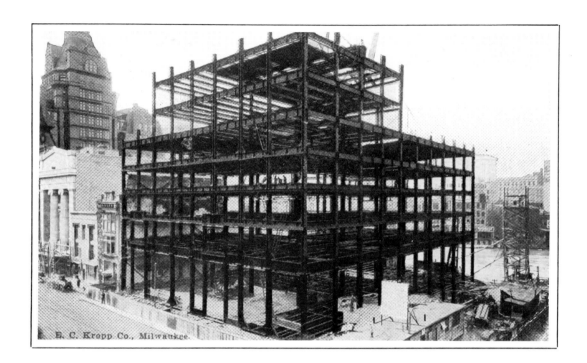

E. C. Kropp Co., Milwaukee.

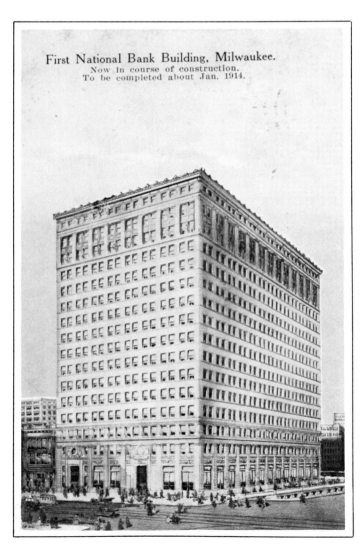

First National Bank Building, Milwaukee.
Now in course of construction.
To be completed about Jan. 1914.

Buildings under construction are not typical postcard views, but apparently someone thought that this 1912 scene of the structural frame of the First National Bank - once the largest such organization in the State of Wisconsin - would find a ready market and make a few dollars for the publisher. D. H. Burnham & Company of Chicago designed this sixteen story structure; it is faced with granite on the first four floors, and buff colored pressed brick on the remainder. Interior corridors are wainscoted in marble. Classical ornamentation adorns the crest, as well as elsewhere on lower floor levels.

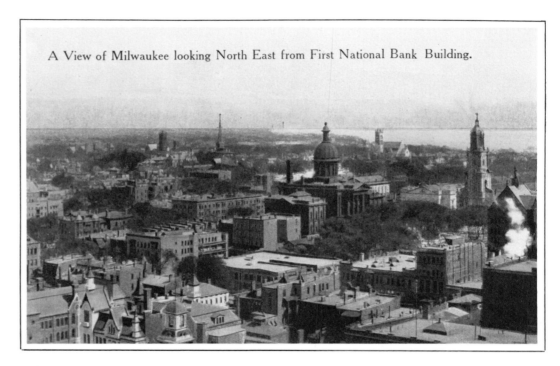

A View of Milwaukee looking North East from First National Bank Building.

A view from the First National Bank Building today reveals that all of the church towers in this postcard scene still stand, and a photograph taken in this latter day will provide a chance for a visitor to this spot to make interesting comparisons.

Next to Waldheim's stood the Marshall & Ilsley Bank, at 721 N. Water. Designed by Brust, Phillip & Heimerl, this neo-classical limestone building was built in 1911 and levelled in 1980. Note the carved stone lions, presumably symbolizing strength.

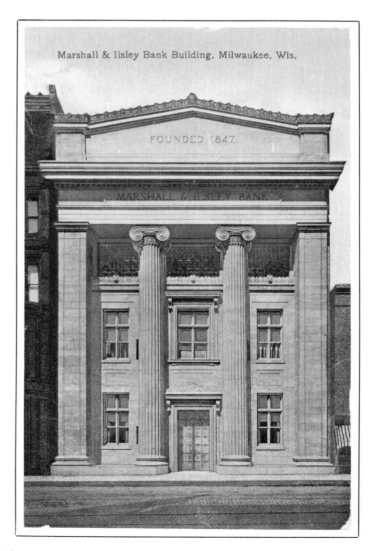

Marshall & Ilsley Bank Building, Milwaukee, Wis.

FOUNDED 1847.

MARSHALL & ILSLEY BANK

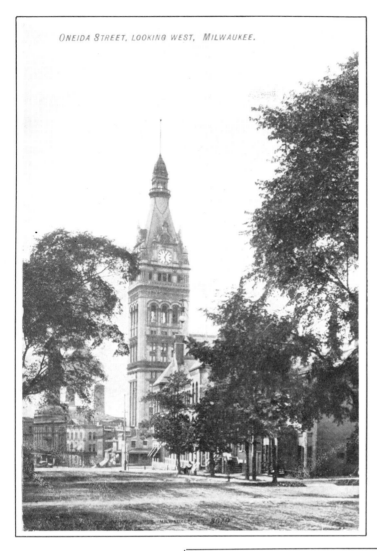

Oneida Street is known today as Wells Street; Milwaukee's first electric street car ran on it in 1890. City Hall, designed by H.C. Koch and built between 1893-5 officially opened on December 30, 1895. Its granite base is topped by a twenty-foot band of Berea sandstone, with St. Louis pressed brick and terra-cotta trim facing the rest of the construction. Tennessee marble and fine oak panelling and woodwork is found on the interior and the city council chambers are a sight to behold, with their rich carvings and beautiful stained glass. The Flemish Renaissance design makes it unique among large city halls in America, and the construction of the 350-foot tower with its 40-foot flagpole was in itself quite a feat. Housed inside is a ten-ton bell, said to have once been the third largest in the world. It is rung only on Independence Day out of concern that vibrations set up in the masonry structure will unnecessarily weaken the tower. The unusual electric sign on the facade of the building continues to carry messages of interest to those passing by; it has done so ever since 1895. A fire in 1930 destroyed the top of the tower; another change is a copper roof which replaced the original slate roof.

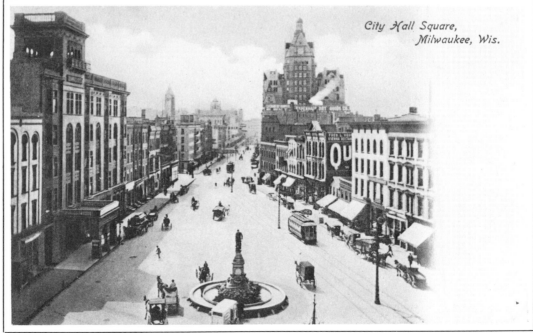

City Hall Square, Milwaukee, Wis.

A visitor to the tower of City Hall years ago would have seen this view, looking south on Water Street. The statue is of Henry Bergh, founder of the American Humane Society, the only statue in America erected in his memory. It was placed here in 1891. Surrounding its base was a watering trough for the benefit of the many horses on the streets in those days; it was filled in with soil and flowers when horseless carriages became more prominent and by 1961 everything was gone. The statue now stands at 4151 N. Humboldt Boulevard on the Milwaukee's north side.

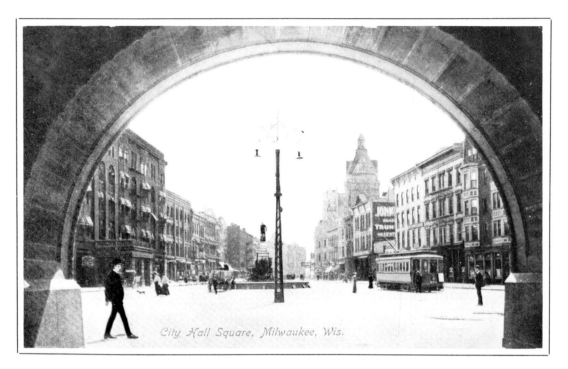

City Hall Square, Milwaukee, Wis.

The same scene as the previous card, but looking out from the entrance arch of City Hall at the street level. Note the Pabst Building in the distance, and the early electric street lighting equipment.

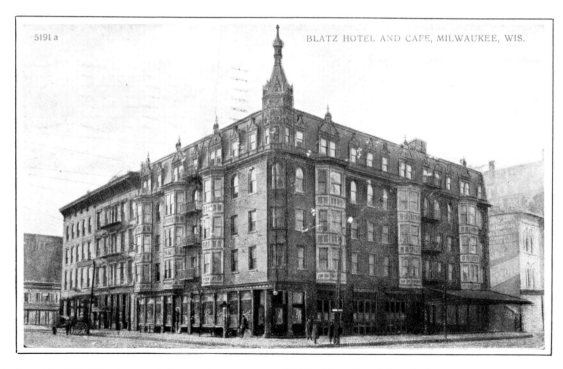

5191 a BLATZ HOTEL AND CAFE, MILWAUKEE, WIS.

The Blatz Hotel and Cafe, designed by Otto Strack, was at the southwest corner of Wells (then Oneida) and Water Streets, kitty-corner from City Hall — thus providing a convenient watering and feeding place for the local politicos and city employees. It is now a parking lot.

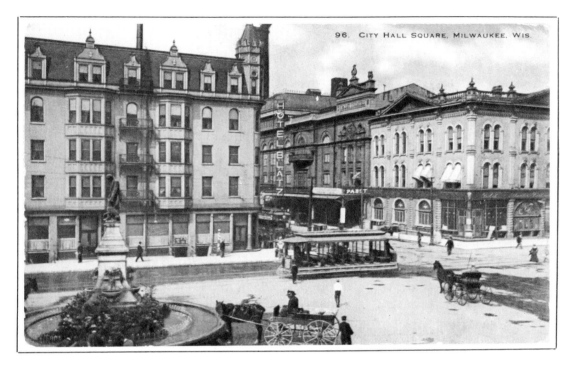

96. CITY HALL SQUARE, MILWAUKEE, WIS.

On the northwest corner of Wells and Water, also facing City Hall Square, was the Pabst Theatre and Cafe. During the summer months 'open air' street cars were put into service. Faithful old Dobbin prepares to take a refreshing drink from the watering trough surrounding the statue of Henry Bergh, who surely would have been pleased to be associated with this convenience designed to serve the animal population of Milwaukee. Note the interesting vertical sign on the Hotel Blatz.

The Pabst Theatre at 144 E. Wells (the building with the sidewalk canopy) was designed by Otto Strack in 1893 and opened in 1895. Originally another section similar to the building at the right stood where the present theatre now stands; opened as Nunnemacher's Grand Opera House in 1871, this western half burned in 1893. Both sections as seen here survived together until the street was widened and the cafe portion, which was a men's hangout where a 'free lunch' was available along with the beer, was demolished in the 1930's.

Wednesday night was German Heritage night featuring outstanding stage

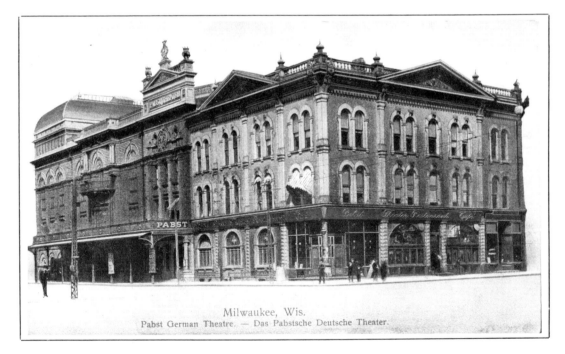

Milwaukee, Wis.
Pabst German Theatre. — Das Pabstsche Deutsche Theater.

presentations with players often direct from the Stadt Theatre in Berlin. In 1917, when 'Der Gewiss'n Wurm' was to be presented, anti-German protesters gathered outside the building with intent to cause structural damage and personal injury should the show proceed, and the police had to break up the uprising. The show went on, but it met with financial disaster and proved to be the end of German Theatre presentations in Milwaukee. The nation was engaged in the World War, and feelings against ethnic Germans was strong throughout the country.

But movies had become the rage in this era; in 1928 the Pabst became a movie house and it looked as though the likes of Caruso and other stars would never shine again in this acoustically fine theatre. In the early 1970's the house closed and awaited a sad end. But fortunately for our and future generations, a successful restoration program was started in 1974 and in 1976 the Pabst Theatre reopened, restored to its former beauty. The opulent interior's gilded ornamentation glistens along with the gold-leafed music harp and urns on the exterior of the building. Original seats still remain in the upper balcony, with the letters of Pabst displayed in the iron castings that form the seat backs. The iron work on the exterior was executed by Cyril Colnik, and an exceptional terra-cotta bust of a lady is a notable feature over the small balcony on the front of the structure.

45

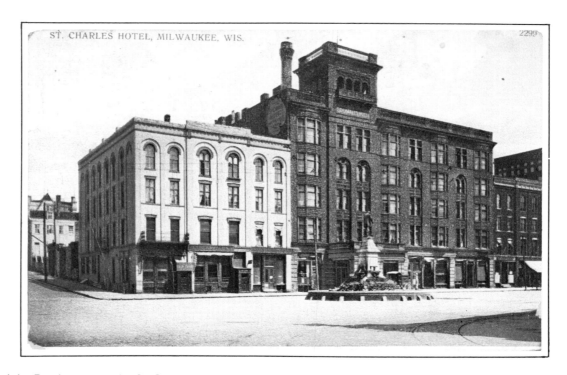

Directly behind the Bergh statue is the St. Charles Hotel, originally known as the Pabst Hotel when it opened on January 1 of 1892.

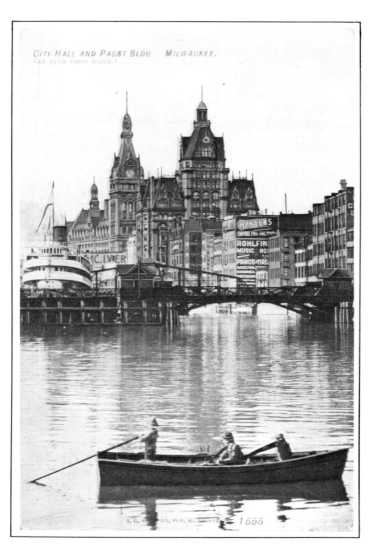

The view northward on the Milwaukee River, from just south of the Michigan Street bridge: The skyline features the towers of City Hall and the Pabst Building, and the steamer Christopher Columbus awaits tourists for a pleasant day's outing.

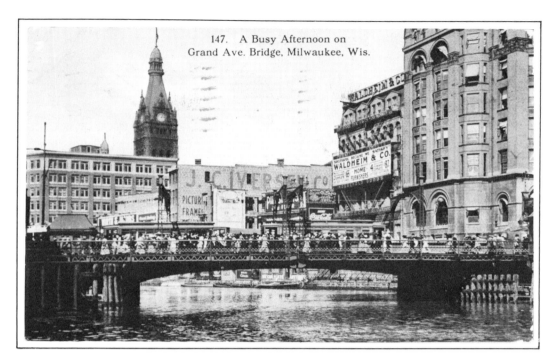

147. A Busy Afternoon on
Grand Ave. Bridge, Milwaukee, Wis.

Our boat ride along the river reveals a great throng of downtown shoppers on the Grand Avenue bridge (Wisconsin Avenue today). In addition to the architectural signs, the local merchants have thrown in some free 'commercials' to add to the interest of the scene. Waldheim's advertises that just $65 will purchase three rooms of furniture, and four rooms complete for only $87.

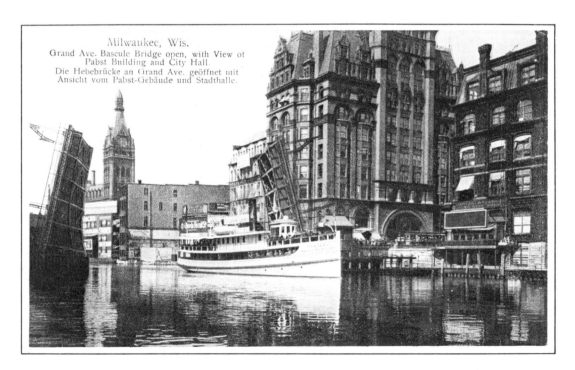

Milwaukee, Wis.
Grand Ave. Bascule Bridge open, with View of
Pabst Building and City Hall.
Die Hebebrücke an Grand Ave. geöffnet mit
Ansicht vom Pabst-Gebäude und Stadthalle.

All traffic stops and an early-day urban gridlock is created as the bridge goes up amid the clanging of the bridge tender's warning bells. Here we see the "Virginia" heading downriver, perhaps to take a group of excursionists to visit the Pabst Whitefish Bay Park.

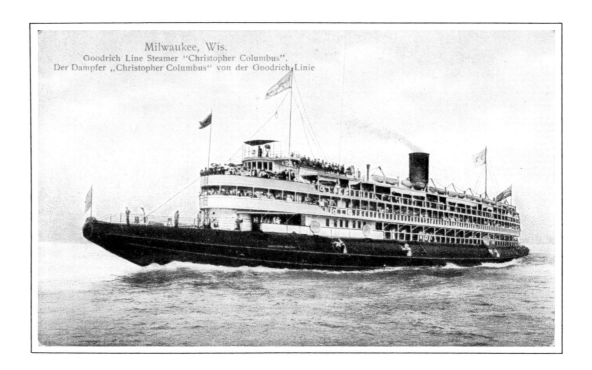

Milwaukee, Wis.
Goodrich Line Steamer "Christopher Columbus".
Der Dampfer „Christopher Columbus" von der Goodrich Linie

"Whalebacks," so called because of the shape of their hulls, served for many years on the Great Lakes as bulk commodity haulers. Of the 43 such vessels, The Christopher Columbus was the only one made for passenger service; it was the twenty-eighth built and was constructed in 1892-93 at Superior, Wisconsin by the American Steel Barge Company for the World's Fair Steam Ship Company. When the Goodrich line acquired the ship in 1898, an additional deck was added. Rated at 1152 gross tons, the craft was 362 feet long and had a 42-foot beam, and was equipped with a 4,000 horsepower engine driving a single 18-foot screw to provide a cruising speed of twenty mph. Four thousand passengers could be accomodated within the beautiful oak-panelled interior, and during the Columbian Exposition 1,700,000 were carried. On June 30, 1917, while navigating in the inner harbor of the Milwaukee River the ship struck a steel support of a water tower on the water's edge; the tank fell, crushing the front deck section and 17 people were killed. The ship was repaired and continued in service until 1932, when the Goodrich Lines ran into financial difficulties. The last voyage was to Manitowoc in 1936, where the great ship was cut up for scrap with the remains being sold to Japan . . . only to come back at us with a vengeance five years later. The captain's wheel survives; it found its way to a permanent home in the local history room of Milwaukee's main library on Eighth Street and Wisconsin Avenues.

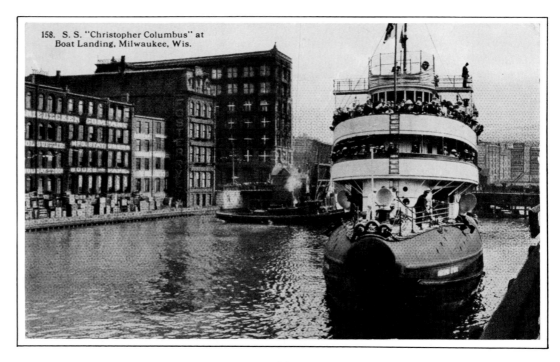

158. S. S. "Christopher Columbus" at
Boat Landing, Milwaukee, Wis.

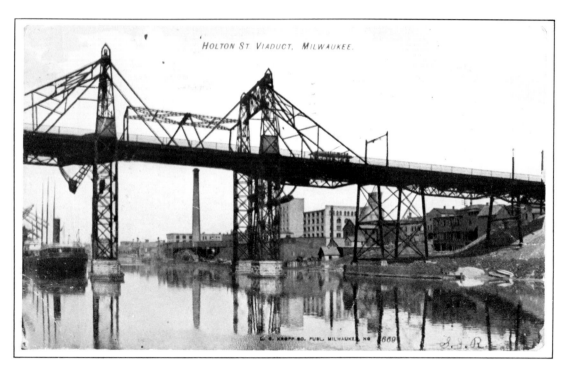

HOLTON ST VIADUCT, MILWAUKEE.

The Holton Street Viaduct silhouettes interesting geometric patterns against the sky. Its structural framework was designed to swing the deck upwards to provide for passage of tall vessels. Note the early trolley car and the support for the catenary which provides its energy supply. Modern city buses have never equalled the good old-fashioned trolley cars in their ability to move lots of people quickly throughout cities, and communities all over America have come to regret having junked their street railway mass transportation systems in favor of what seemed at the time to be an attractive alternative.

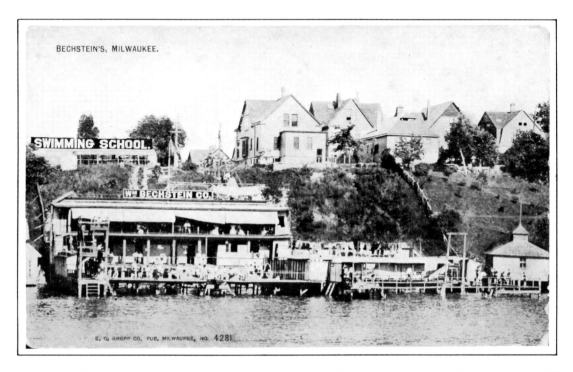

BECHSTEIN'S, MILWAUKEE.

SWIMMING SCHOOL.

Wᴹ BECHSTEIN CO.

Bechstein's Swimming School was the most popular of several such establishments which could be found on the Milwaukee River. As early as 1905 the business was listed at 1053 Cambridge Street. William was the proprietor, and at various times his brothers Carl A. and Herbert assisted. Most of these schools were gone by the 1930's, but Bechstein's held on until 1940 when it closed following William's death in January 1 at the age of 74. The magnificent tree-lined banks of the Milwaukee River are as beautiful today as when these schools were at their height; few cities are so fortunate as to have such natural scenic beauty so close to downtown.

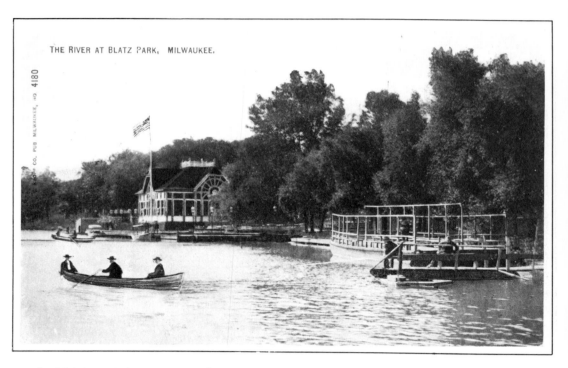

THE RIVER AT BLATZ PARK, MILWAUKEE.

In a day when most working people didn't have their own means of transportation, most folks got to places like the Blatz Park Pavilion by streetcar or by boat. Upon arrival, many a pleasurable hour was spent boating or picnicking in the wooded grove adjoining the river. Most of these parks were in operation from the 1880's until 1919, when the Volstead Act — more commonly known as 'Prohibition' — was passed and consumption of anything stronger than 3.2% beer became illegal throughout the land.

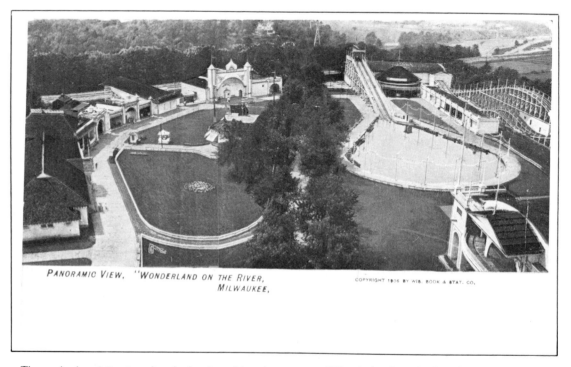

PANORAMIC VIEW. "WONDERLAND ON THE RIVER, MILWAUKEE,

COPYRIGHT 1905 BY WIS. BOOK & STAT. CO.

The early-day visitor traveling by boat could make a stop at "Wonderland on the River" (the river is in the background), or access could be by the Oakland Avenue trolley. This popular amusement park started as "Lueddemann's on the River" in the 1850's, but by the turn of the century was known as Mineral Springs Park; for a time it was also known as Coney Island Park.

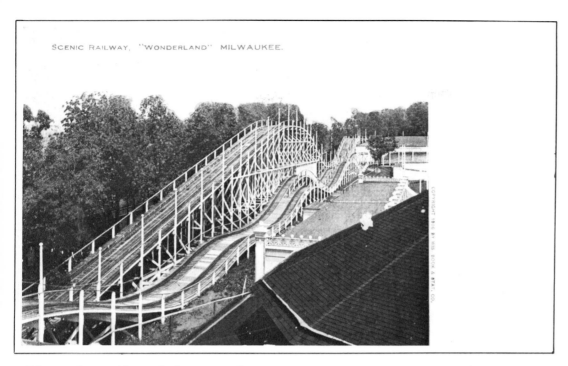

SCENIC RAILWAY, "WONDERLAND" MILWAUKEE.

What we know today as "roller coasters" were more typically called "scenic railways" years ago, though it's hard to imagine riders doing very much sightseeing as the cars whipped up and down and around the tracks at breakneck speeds.

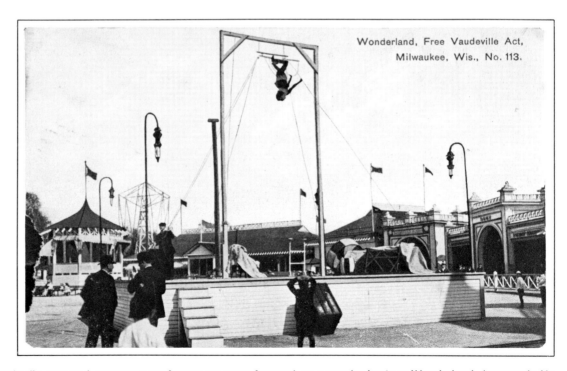

Wonderland, Free Vaudeville Act,
Milwaukee, Wis., No. 113.

In addition to the rides, vaudeville acts and gymnastic performances were featured on a regular basis at Wonderland. Apparently Mr. Edison's invention had not yet made its way to the park at the time the photo was made, judging by the presence of gas light fixtures.

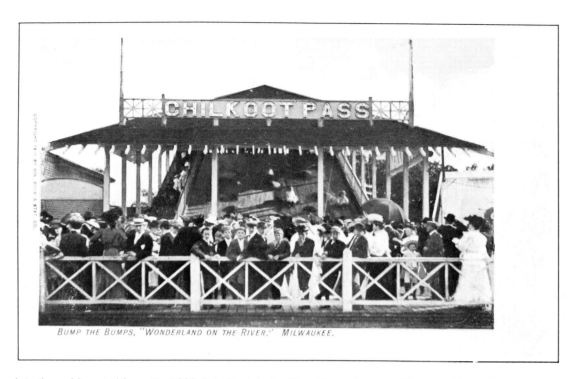

BUMP THE BUMPS, "WONDERLAND ON THE RIVER," MILWAUKEE.

Chilkoot Pass was very much in the public mind from the 1898 Gold Rush in the Klondike region near Skagway, Alaska. Everyone had seen the famed photograph of the long line of miners struggling up the snowy slopes, attempting to reach the area where each hoped against hope that great fortune awaited. It seems only logical that amusement park managers would attempt to catch the public's fancy by attaching the famous name to downhill rides in place of more mundane titles like "Bump the Bumps".

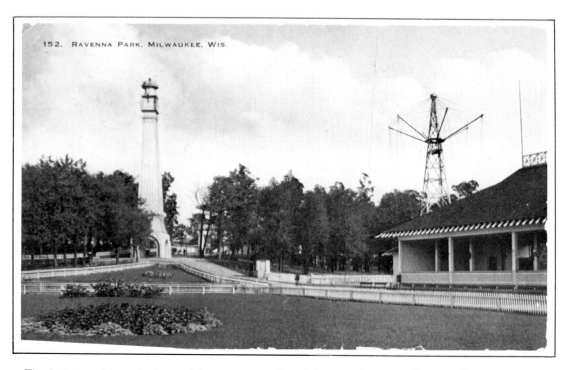

152. RAVENNA PARK, MILWAUKEE, WIS.

The last time this park changed its name was when it became known as Ravenna Park, at which time new rides were added in an attempt to attract new customers.

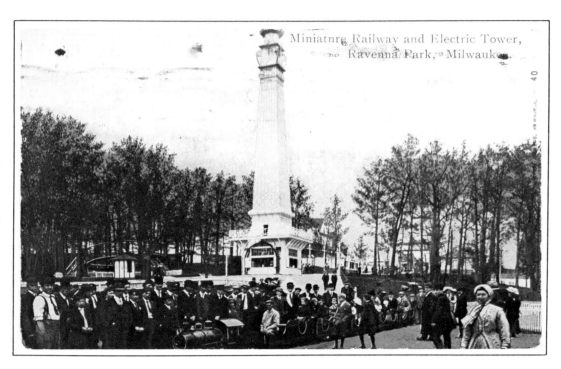

Lives there a railfan who could fail to "go ape" over this nifty miniature steam railway? Behind the train is the observation tower which was illuminated by over 1000 light bulbs, a real electrical extravaganza for its day. The light of life was to go out for this park, however, for it was abandoned around 1920. The south section became a terminal yard of the street railway company, but the north section met with a more appropriate fate; the Village of Shorewood purchased it and it became Hubbard Park. The roar of the roller coaster, the bark of the side show hawker, and the happy sounds of the merry-go-round may be but memories, but a fine picnic or family outing can still be yours at this beautiful park.

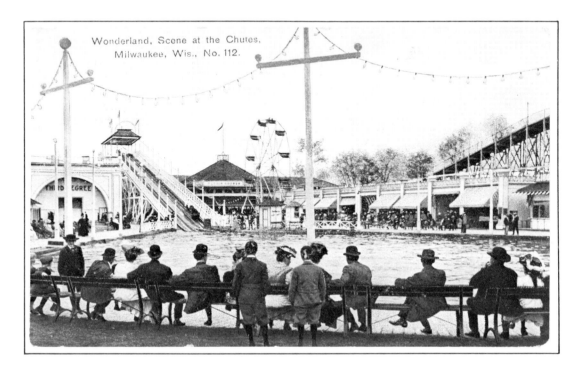

A favorite ride of any amusement park has always been some type of water slide. "Shoot the Chutes" were very popular in early American parks, with a flat bottomed sled-shaped wooden boat first gliding through a "Tunnel of Love" where minor romancing might take place between a swain and his girl, to be interrupted by the tow up an incline, followed by a swift drop down the opposite slope to a great splash into the pool below. Today's amusement parks, with their sophisticated and high-tech apparatus, are more apt to have such a ride in the form of a 'log flume', with the boat having become a fiberglass log, and the flume taking on all sorts of interesting twists and turns. But the idea hasn't changed one iota.

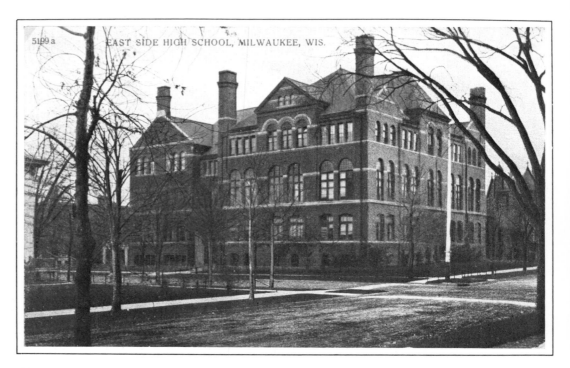

5199a EAST SIDE HIGH SCHOOL, MILWAUKEE, WIS.

Back to reality from the joys of the amusement park! After Riverside High opened this facility became known as Lincoln High School. The building was declared unsafe in 1914, but continued to be used until 1930 when it was demolished, to be replaced by the structure which stands today. The building pictured was at the northeast corner of Cass and Knapp Streets and today the site is the playground of Lincoln High School.

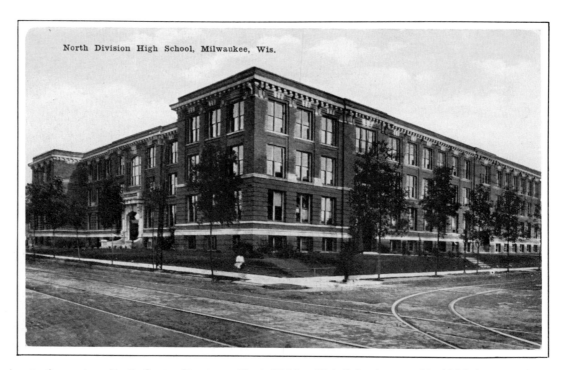

North Division High School, Milwaukee, Wis.

Across the river to the west on North Center Street was North Division High School, opened in 1906. A new architectural concept for school construction dictating fewer stories but more land area; North Division was considered quite a radical departure from conventional thinking. This building served the community until it was closed in 1977 and then leveled. Now a sleek and mostly windowless version can be found west of this location.

54

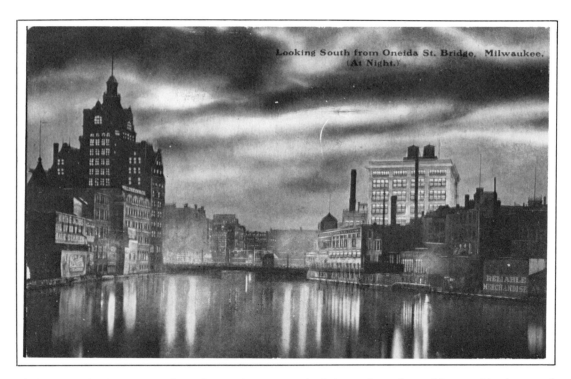

Looking South from Oneida St. Bridge, Milwaukee. (At Night.)

The visitor to Milwaukee who has spent a long day on the river can look forward to a beautiful scene like this, combining the sunset with gas and electric illumination of the downtown area. A place to stay? Never a problem, for there are many fine hotels awaiting one's patronage. Our guide at that earlier time might well have suggested staying clear of the area on the left, the community's "red light" district. But our guide today would encourage a visit, for it now features the Performing Arts Center and is the city's theatre district where we can absorb our fill of Milwaukee's many cultural opportunities.

Another gridlock situation on Grand Avenue! Bascule bridges have a way of bringing everything to a quick stop; this one was constructed in 1906 and spanned the river until it was replaced in 1980. The Pabst building is across the river on the left, and on the right is Gimbel's Department Store. The electric car and the two trolleys are reminders of an earlier time, when pollution from auto and truck exhausts was an unforeseen problem of the future.

The streets on the east side of the Milwaukee River do not line up with those on the west, thanks to disputes which arose during early settlement days. Before

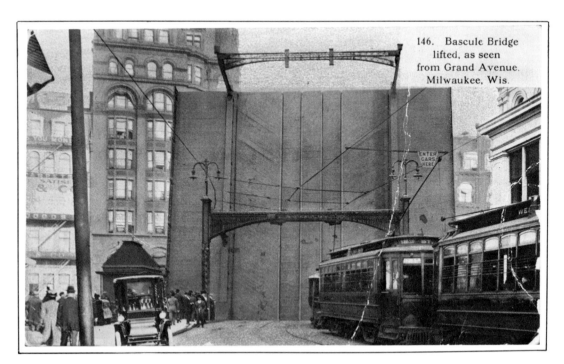

146. Bascule Bridge lifted, as seen from Grand Avenue. Milwaukee, Wis.

1846 there were three sections, Kilbourntown, Juneautown, and Walker's Point, with each vying for dominance with many disputes resulting with consequent misalignment of the streets. The eastsiders of Juneautown paid for several bridges to their neighbors, but eventually decided to invest no more in river crossings. When a schooner rammed the Chestnut Street bridge, the incident touched off what became known as the "Bridge War of 1845." The westerners decided they would not pay for repairs, so they demolished their half of the bridge and the eastern half fell into the river. The Juneautown folks were so enraged that they secured a cannon, loaded it with clockweights (since they had no cannonballs) and aimed it at Kilbourn's residence. Efforts at peace failed, and the eastsiders then smashed both the Wisconsin and Menomonee bridges as well. It soon became apparent to all that one city government was needed; reason prevailed, and in 1846 the three towns were consolidated to form the city of Milwaukee.

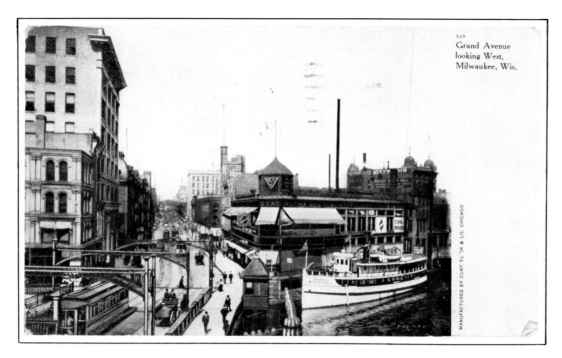

This and the next two views are an adventure in time-lapse photography; note carefully the buildings on the right, including the domed structure, of which more later. Part of the old section of Gimbel's Department Store is on the left. The old Caswell Block, built in 1854, is here, and immediately to the west the Dime Museum operated by Jacob Litt who also managed the Bijou Theatre as 631 N. Second Street, the Schlitz Palm Garden, and the Academy of Music.

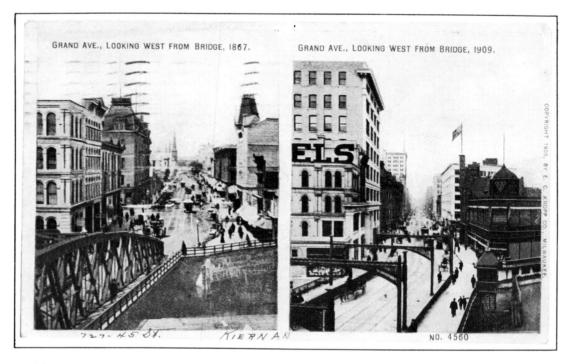

An interesting combined view of Grand Avenue that shows downtown development over a 42-year period: Gimbels has acquired a lettered sign, and a large white building in the distance, the Majestic Building, has been erected, and the bridge is new. The Caswell Block would eventually appear to replace the building at the right. In another card not included in this book a large billboard appears just to the right of this scene; it promotes Browning King & Company, a chain of men's clothiers that was well-known throughout the northeastern part of the United States, and which catered to the well-to-do and whatever they called yuppies in those days.

WISCONSIN AVE. LOOKING WEST
MILWAUKEE, WIS.

The horse and buggy is pretty much a thing of the past, as cars now line the Wisconsin Avenue of the 1920's. Gimbel's department store is now completed and looks as it does today. The old Plankinton Hotel block has been replaced with a new "arcade" office building on the left side of the street past Gimbel's. Gone is the Empire Saloon and now the Empire Block occupies the site with a beautiful silent movie palace, The Riverside Theatre. The view is essentially the same today. The Riverside was almost lost to mere office space, but preservation-minded groups and individuals managed to save it for use as a live performance theatre, and it has been restored to its former elegance. It is well worth the price of admission to a show just to see this spectacular show house. Architects Charles Kirchhoff and Thomas Rose designed the 2557-seat Riverside which was opened in 1929, featuring a three-manual thirteen-rank WurliTzer theatre organ whose glorious sounds still entertain audiences with its buzzing kinura pipes, throaty diapasons, and lush outpourings generally characteristic of this type of instrument.

The Gimbel Brothers located their store on Wisconsin Avenue, along the Milwaukee River. They started business in Indiana, but soon moved their operations to Milwaukee, in 1887 — and they bought each section of the block piece by piece as they prospered. The 420-foot-long white glazed terra-cotta-faced complex seen here was remodeled to its present unified appearance by 1925. Sales facilities were also opened in New York and Philadelphia. Once considered "The Place to Shop," the doors of this store closed in 1986, and Gimbel's ceased to be a Milwaukee tradition. Another department store chain purchased the property and continues to do business at this historic site.

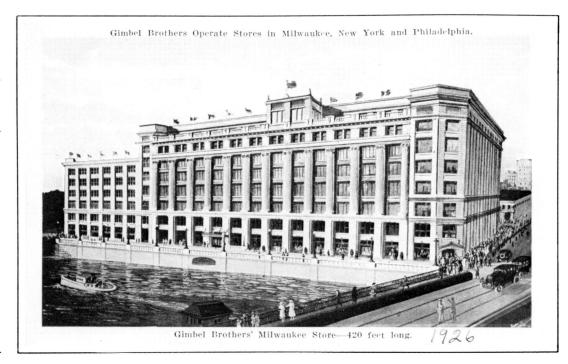

Gimbel Brothers Operate Stores in Milwaukee, New York and Philadelphia.

Gimbel Brothers' Milwaukee Store—420 feet long. *1926*

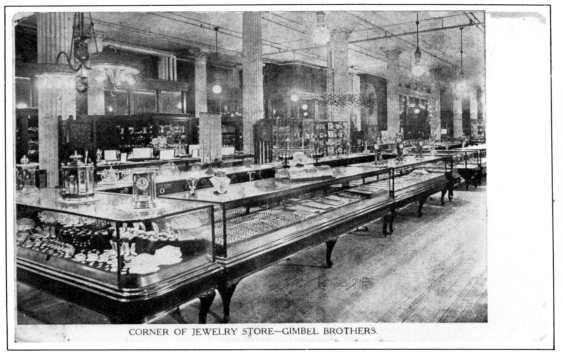

CORNER OF JEWELRY STORE—GIMBEL BROTHERS.

Inside Gimbel's at the turn of the century we see a fine display of jewelry and crystal regulator clocks. The interior electric lighting was accomplished by a combination of arc illumination and incandescent bulbs. Today's remodeled interior reflects little of this period, though the large clock over the entrance carries on its job of reminding shoppers, as it did decades ago, that they still have time to find what they want and to drop some cash into the till in exchange. Or more likely, today, to hand over a credit card in place of the real thing.

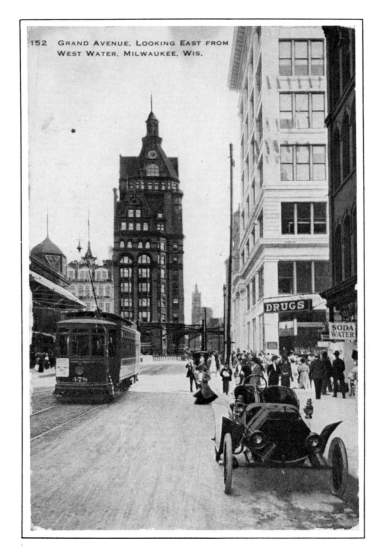

152 GRAND AVENUE, LOOKING EAST FROM WEST WATER, MILWAUKEE, WIS.

Further west on Wisconsin Avenue, from in front of the Plankinton Block, Gimbel's is seen on the right and the Pabst Building in the center. Note that an artist has carefully removed (by air brushing or some other technique) the overhead wires that power the electric street cars, thus suggesting that the street scene is a lot less cluttered than it actually was. Many of the scenes in this book have been enhanced this way; postcard publishers have never been above doing a little embellishing to improve the salability of their products. The car facing the camera features right-hand drive, a not-uncommon arrangement in the early days of America's automotive industry.

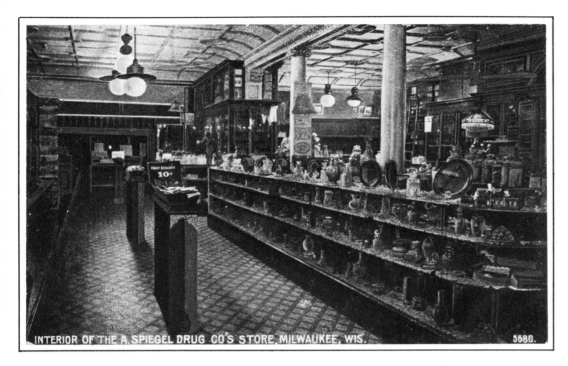

INTERIOR OF THE A. SPIEGEL DRUG CO'S STORE, MILWAUKEE, WIS. 5580.

The Spiegel Drug Company operated stores in the heart of the city at the turn of the century at 238 W. Water Street, 199 Third Street, and 181 W. Water Street. On the proceeding card the "Drugs" sign appears and on the following card is seen the "egel Co." which is the tip of their advertising sign. The firm went out of business in 1918, following Mr. Spiegel's death in 1917. This interior illuminated by arc lights is a nostalgic view back in time to when ten cents would purchase a fair amount of merchandise.

File 106-110 109

Here's the Plankinton Block, to which several references have already been made, between West Water (today known as Plankinton Street) and North Second Street. Built in three sections starting in 1868 and completed in 1884 (the Second Street corner section), it housed several offices and businesses including a bank and a hotel. Gimbel's is at the extreme left. One of the

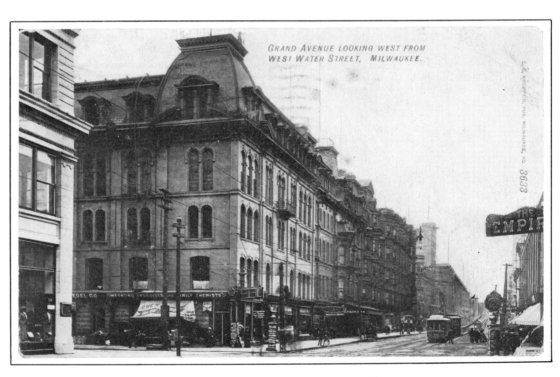

GRAND AVENUE LOOKING WEST FROM WEST WATER STREET, MILWAUKEE.

many street clocks found throughout the city can be seen beneath the "Empire" sign on the lower right. The Milwaukee Journal of November 19, 1977, carried a brief story of the saga of the clocks: ". . . In the 1890's there were about 50 such tower clocks in Milwaukee. Then, Sherburn Becker, Milwaukee's 'boy mayor,' became annoyed by the signs and large clocks in front of Grand (now Wisconsin) Ave. jewelry stores. When the owners refused to remove them, he decided to enforce a city ordinance against sidewalk obstructions and personally headed a picked crew of firemen and policemen who — equipped with sledge hammers, a derrick and rope — demolished most of the clocks 'gleefully.' The clocks came back with Mayor David Rose in 1908, but only to be slowly removed from the scene by electric clocks and wristwatches."

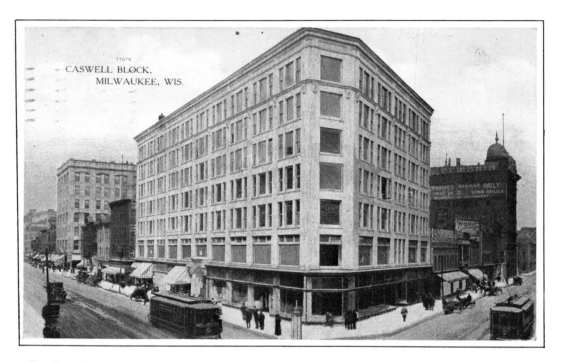

The Caswell Block was built in 1907, on the site where the Spring Street Methodist Church once stood — the building where Solomon Juneau was inaugurated as Milwaukee's first mayor in 1846. (Spring Street became Grand Avenue and finally Wisconsin Avenue). An interesting exterior feature of this building is the pair of white terra-cotta gnomes on either side of the entryway, each holding a date tablet; One is inscribed 19 and the other 07. Note the enclosed police call station on the street corner.

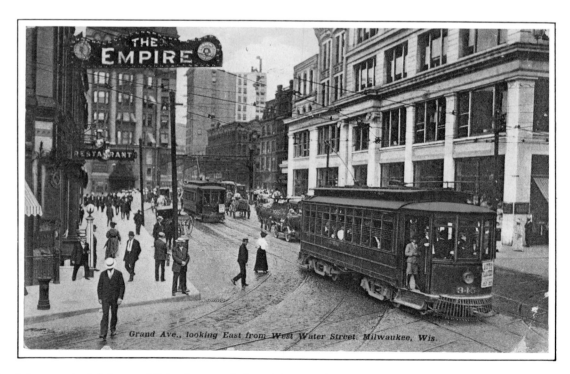

The Empire Saloon at the left featured Pabst beer, and shared space with a restaurant and a barbershop in the building. Gimbel's is across the street, with the right portion of the building in its final form, and two earlier 1880's building facades still standing at the far end. Across the river can be seen the Pabst Building, the Iron Block, and the Railway Exchange Building.

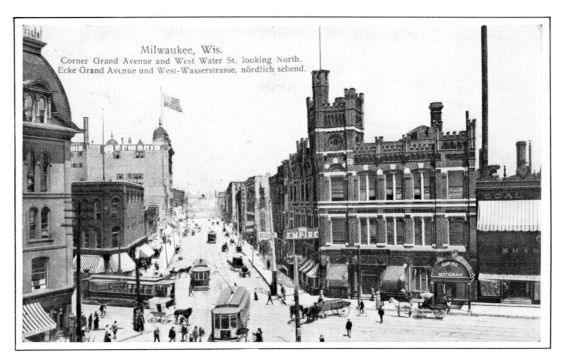

Walk across the street kitty-corner in the previous card, go up a couple of flights, do a one-eighty, and this is the scene with the Empire Saloon right in the middle. Architect Otto Strack re-designed this building (which had been built in 1878), and he designed a number of other Pabst-owned saloons and several of their brewery buildings. The crenelated brick wall design was a real favorite of his, and he used it frequently. Note the Pabst emblem (today we'd call it a logo) on the tower. The Plankinton Block is on the extreme left, with some nifty Victorian crestwork on the top of the mansard roof. The Caswell Block has yet to be constructed on the northwest corner. With the exception of the Germania Building which flies the American flag, everything in this scene is now gone. Notice that the caption on the card is in two languages, German not only for the benefit of those immigrants who had not yet mastered the English language (which even in the late 20th Century had not been designated by the U.S. Congress as being the official language of our country), but for others who could handle English but who might wish to send greetings back to friends and kinfolk back in the Vaterland.

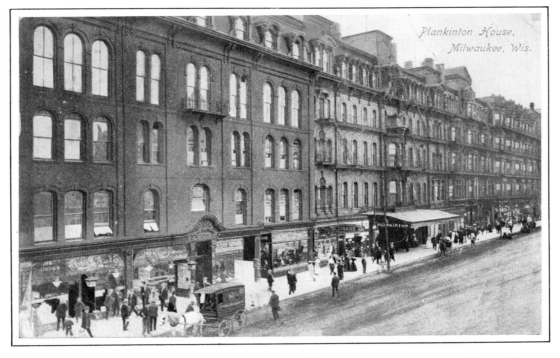

Still another view of the Plankinton Block as it fronts Wisconsin Avenue (West Water then) and North Second Street on the right. The later additions were designed by E. T. Mix.

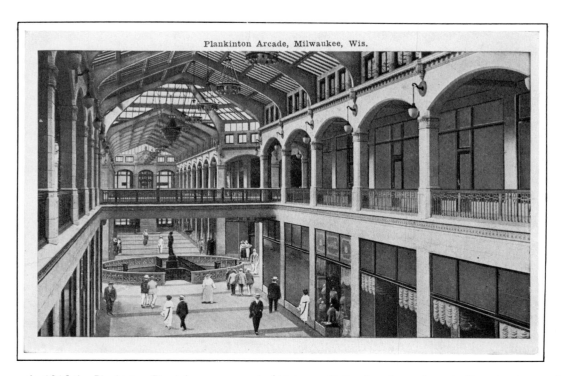

In 1916 the Plankinton Block became a part of history, with the "new" arcade and office structure replacing it. A bronze statue of Mr. Plankinton stands in the center of three curved stairways which descend to the lower section of the arcade; it had previously been in the hotel on the site. The fine arcade became dimmed with time; store fronts were walled in and various modernizations did away with the architect's original concepts and inspiration — but in 1982 this arcade became the focal point for the development of a new mall which opened that year. Today this area appears much is it did in this 1916 postcard view.

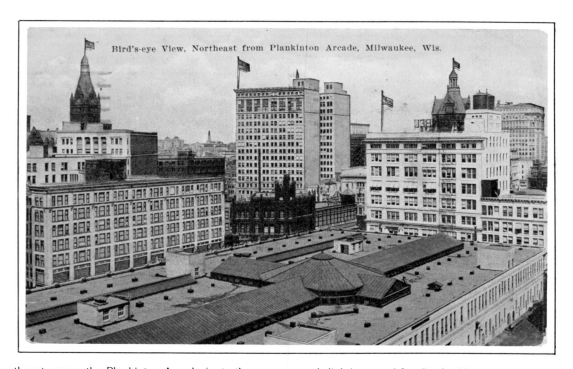

Looking northeast across the Plankinton Arcade (note the enormous skylight), several familiar buildings are apparent at a time when the Victorian flavor of Milwaukee was starting to disappear. The Empire Saloon looked out of place as the "giants" approached the castle. In 1924, five additional floors in the Renaissance style were added to the Plankinton Arcade, and they blended well with the two lower Gothic floors of the base section.

Section of the Largest Bowling Room in the World, Plankinton Arcade, Milwaukee.

A favorite sport in Milwaukee has been bowling, and when the Plankinton Arcade was completed it claimed to have the largest "bowling room" in the World. It was a fine place to escape the winter's cold, and in those pre-air-conditioned times, a nice spot to avoid the summer's heat since it was located in the basement of the arcade.

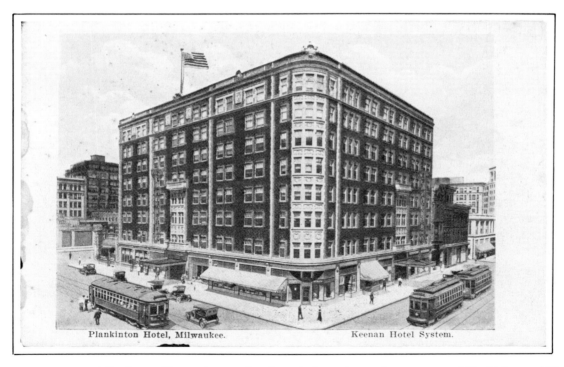

Plankinton Hotel, Milwaukee. Keenan Hotel System.

After the demolition of the old Plankinton House, this new hotel was built on the northwest corner of Plankinton and Michigan Streets. Today, the "guests" checking in at this location are automobiles for a parking structure adjacent to the present-day mall which was built here in 1981.

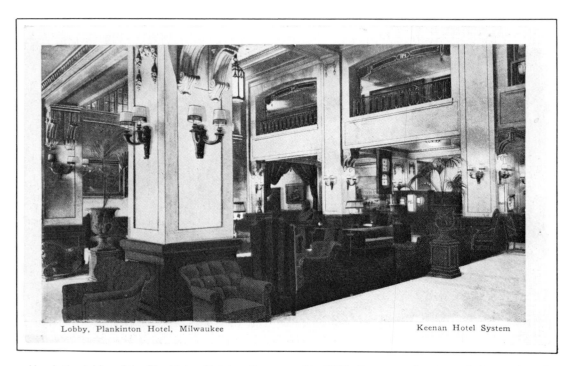

Lobby, Plankinton Hotel, Milwaukee Keenan Hotel System

Here's the lobby of the Plankinton Hotel as it appeared in 1920. Many prominent people kept suites of rooms in this fine establishment, not the least of whom was General Douglas MacArthur.

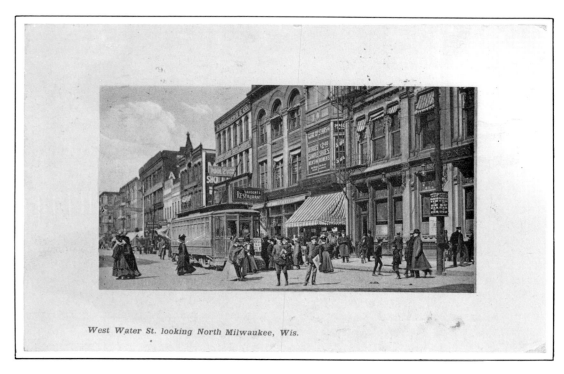

West Water St. looking North Milwaukee, Wis.

A stroll northward up Plankinton (then West Water) Avenue after crossing Wisconsin Avenue takes one past this row of stores on the right side of the street; the Empire Saloon is at the extreme right in the view. By 1910 the rest of the buildings were gone, the victims of economic realities of the time as downtown development demanded newer and taller and more useful structures.

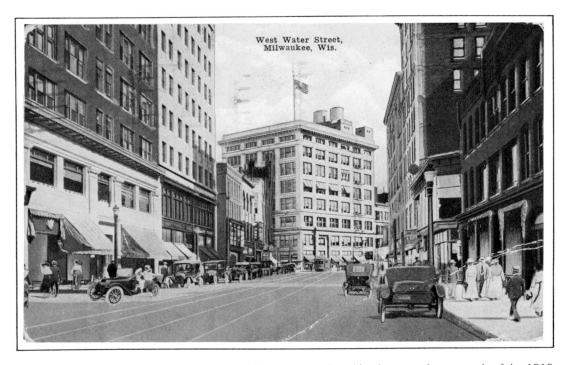

West Water Street, Milwaukee, Wis.

As in the blinking of an eye, time has gone by. Buildings in the previous card are gone, replaced by these modern marvels of the 1910 era on the left side of the picture. Gimbel's is at the center of the view.

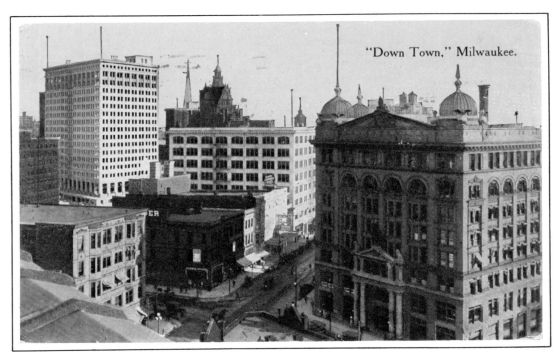

"Down Town," Milwaukee.

One of Milwaukee's most important "downtown" structures, from an historic standpoint, is the Germania Building. Located at the corner of Plankinton and Wells, it was constructed in 1896 in the Classical Revival style with several Romanesque arches. Designed by Schnetszky & Liebert for George Brumder, it became the world's largest German newspaper building. The statue of Lady Germania which stood above the entrance was removed in 1917 at the height of anti-German sentiment during World War I — perhaps partially motivated by resemblance of the copper domes to the helmets of the turn-of-the-century German armies of Bismarck and Kaiser Wilhelm — and her whereabouts are a mystery as she was last seen residing in the basement of the auditorium in 1943. Two great lions are a feature of the exterior of this building with its tan pressed-brick exterior, as are the initials of George Brumder on the facade.

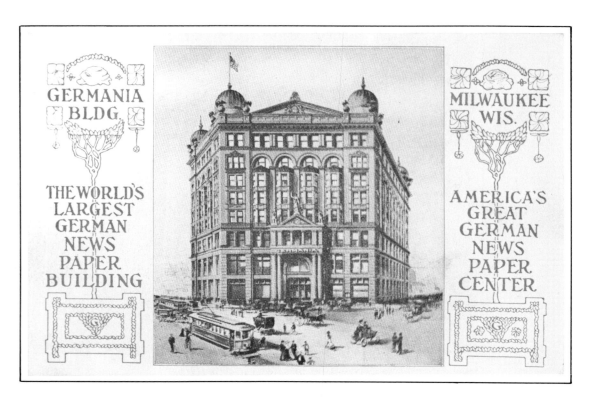

GERMANIA
BLDG.

THE WORLD'S
LARGEST
GERMAN
NEWS
PAPER
BUILDING

MILWAUKEE
WIS.

AMERICA'S
GREAT
GERMAN
NEWS
PAPER
CENTER

This card proclaims the Germania Building as the largest German newspaper building in the World, and fortunately for our generation, much of the original splendor of the place has been returned after years of neglect of both its interior and exterior. Some of the finest office space in the city is now to be found here. The printing facility no longer exists, but many features such as the ornamental ironwork, woodwork, plasterwork, and hardware have been carefully redesigned with painstaking efforts to harmonize with Schnetzky and Liebert's original intent.

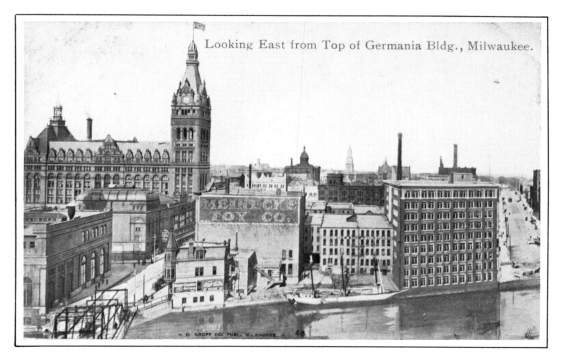

Looking East from Top of Germania Bldg., Milwaukee.

The view looking east from the top of the Germania Building reveals the splendor of City Hall at the upper left. The building at the lower left is the Wells Street Electric Power Station, built in the early 1890's; the interior was a sight to behold. White and gray marble slabs bedecked with ornate electrical gauges and meters fronted by a highly polished brass railing on the upper two levels served to increase the visitor's awe of electricity, this new form of wizardry and wonderful servant of mankind. Rotating steam turbines and electrical machinery hummed for almost 90 years as power was generated here to serve the Milwaukee economic area. The building came close to being demolished, but instead has been saved to come alive again with the energy of actors to entertain the public with the transformation of the area into the city's theatre district. Mason Street is visible at the right.

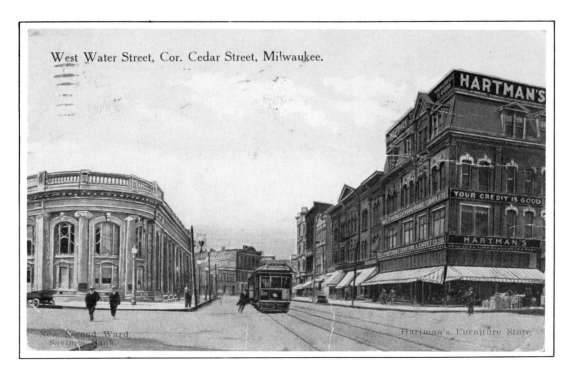

West Water Street, Cor. Cedar Street, Milwaukee.

New Second Ward Savings Bank.

Hartman's Furniture Store

On the left is the Second Ward Savings Bank. Father Marquette camped on the site of the building at the right, it in turn has been leveled to create a riverside park. Marquette was the first white explorer to visit the upper Mississippi River area. Many of these commercial buildings had fascinating interiors that today's Victoriana buffs love to study, such as seen in . . .

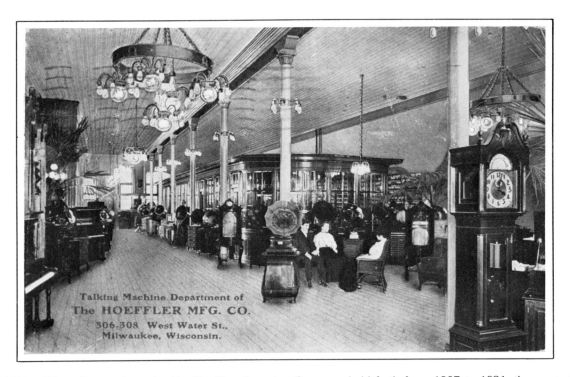

Talking Machine Department of The HOEFFLER MFG. CO. 306-308 West Water St., Milwaukee, Wisconsin.

. . . 306-308 West Water Street where the Hoeffler Manufacturing Company held forth from 1907 to 1921; they were Milwaukee's largest dealer in mechanical music machines in the early days of the twentieth century. Prior locations had been at 258 W. Water St. in 1906 and on the east side at 37 Oneida Street in 1905. From 1921 until the late 1920's the Hoeffler Company was located at 275 Fifth Street, which reflects the address prior to street renumbering in 1930. Note the top-of-the-line Victor VI talking machine at the center of the photograph, as well as several music boxes including two upright Regina automatic disk-changing music boxes, one with stained glass in its door and a clock in its decorative carved wooden finial. On the left are several 'automatic pianos' made for places like saloons and billiard parlors to operate by insertion of coins from their patrons in the same manner as latter-day 'juke boxes' are used. The large WurliTzer orchestrion (an orchestrion is an automatic piano fitted with drums, traps, organ pipes and other paraphernalia to similate a small orchestra) was sold to a saloon in Green Bay, Wisconsin, and fortunately has survived in a prominent collection to be enjoyed by today's and other generations of music lovers.

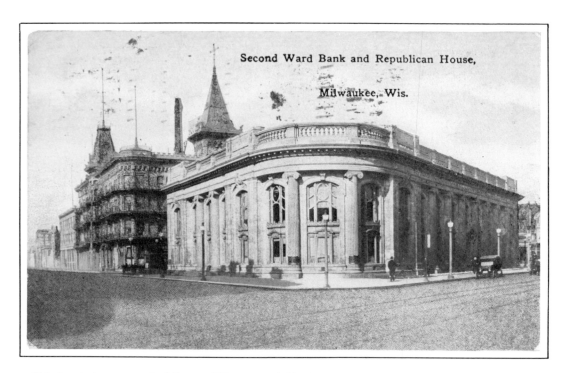

This lovely beaux-arts building at Kilbourn and Plankinton Avenues was the home of the Second Ward Savings Bank. It was constructed in 1913 of Bedford Limestone to designs of architects Kirchhoff and Rose. In 1965 it became the headquarters for the Milwaukee Historical Society, and today many fine exhibits await the visitor's discovery upon a voyage to Milwaukee's past.

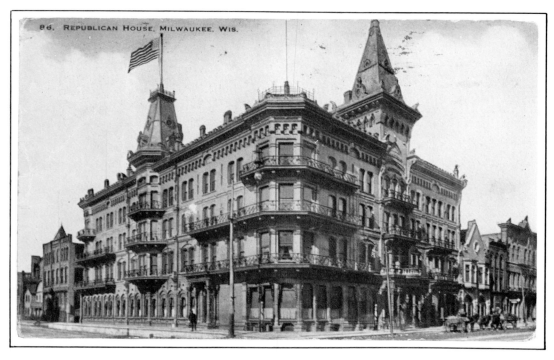

The Republican House used to stand at 907 N. Third Street; this imposing Victorian hostelry was designed by architect F. Valguth in 1884. As late as 1940 it was noted that the ladies' parlor was still furnished in the Victorian style, and the wood-panelled dining room and bar were still extant. Numerous political rallies were held here before the site was converted to a parking lot for the Milwaukee Journal Company, located diagonally across the block at Fourth and State Streets.

The "Buffet and Main Bar" of the Republican House was strictly a male bastion when advertising slogans like "You've come a long way, baby," were far in the future.

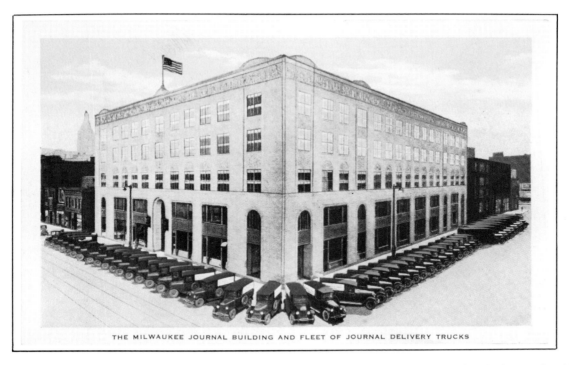

THE MILWAUKEE JOURNAL BUILDING AND FLEET OF JOURNAL DELIVERY TRUCKS

The Journal Building is shown here with a spiffy fleet of trucks in a precision line-up reminiscent of battleships at Pearl Harbor. It was designed by Chicago architect Frank Chase in 1924, who included a frieze of stone carving depicting the history of printing and news distribution. The Milwaukee Journal Company was founded in 1882. The card is a rare one, and your author was obliged to pay the princely sum of $10 for it at a flea market — a substantial amount for any postcard! The card was evidently issued by the Journal, for the message on the back is as follows:

"Centrally located on Fourth and State Sts., Milwaukee, the beautiful Renaissance type building occupied exclusively by the Milwaukee Journal is excellently situated for the production and distribution of newspapers. It enjoys distinction as one of Milwaukee's finest edifices. In this model plant conditions are ideal for the 860 workers who daily put out The Journal. The annual Journal payroll is $2,243,195. In the picture are seen the major part of The Journal's 56-truck fleet which delivers The Milwaukee Journal in Milwaukee and surrounding counties. These trucks traveled a total of 1,007,028 miles last year [The card does not say what year, but probably around 1926 or 28. ed.] the equivalent of 40 trips around the world."

Across the street from the Journal Building, at 318 W. State Street, Christopher Latham Sholes built his first typewriter in 1869.

69

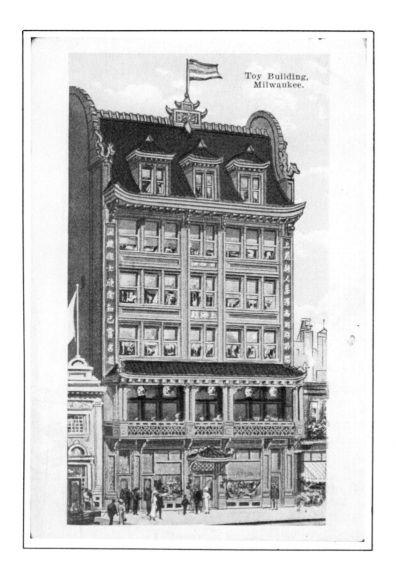

Toy's Restaurant at 720 N. Second Street opened in 1912 and in its original Chinese format was one of Milwaukee's more interesting restaurants to visit. Between the years of 1915-24, a 460-seat silent movie theatre coexisted at this location.

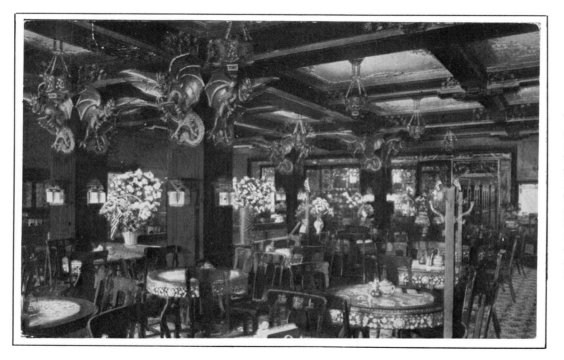

Dining at the original Toy's Restaurant was an exotic experience, as one might easily surmise from this picture, what with winged dragons crouched beneath ceiling beams as if to strike out at the unwary guest. The building is gone, but fortunately this great restaurant carries on its traditions a short distance away, at 830 N. Third Street.

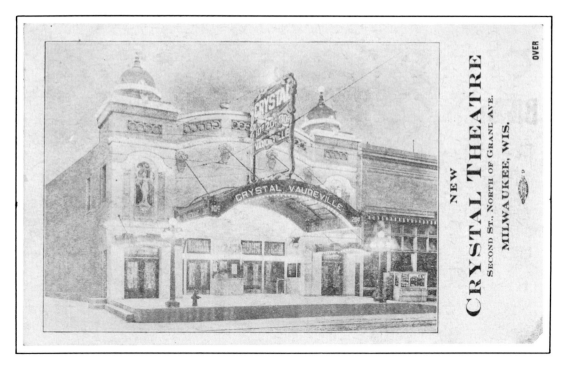

The Crystal Theatre opened in 1903 to designs of Leiser and Holst, but in 1907 it closed to be redesigned to a 1032-seat house by Kirchhoff & Rose — after which it continued in operation until 1929. Subsequently it saw service as a nightclub, but was eventually demolished.

The Loan and Trust Building built by the Plankinton family in 1889 stood at the northwest corner of Second and Wisconsin Avenues. The street clock on the corner was one of the many which stood on Milwaukee streets before Mayor Becker started his clock bashing forays, wiping out many of these fine timepieces, much to the dismay of today's antique horology buffs.

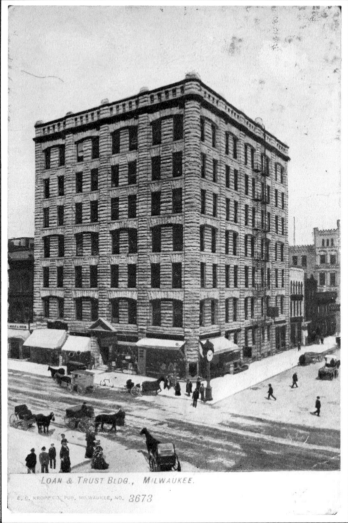

71

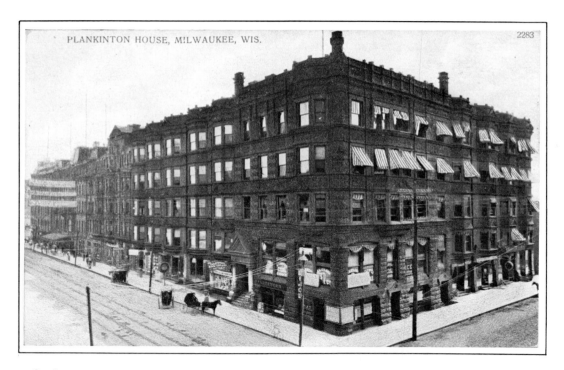

On the southeast corner of Second and Wisconsin stood the other section of the Plankinton Block; together they covered an entire city block. When the Plankinton Hotel was remodeled and extended in 1884 it boasted 450 rooms of which 200 had baths; Edward T. Mix designed it of brown sandstone. This entire structure was leveled in 1915 to make way for the present Plankinton Arcade.

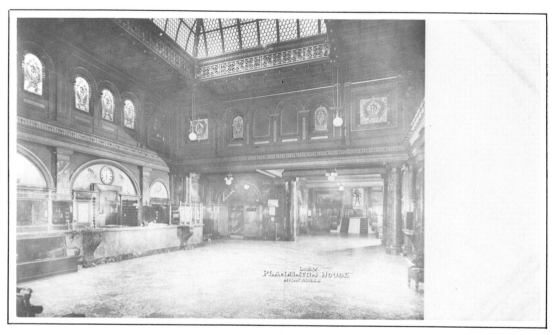

Architect E. T. Mix liked open areas in his building projects, as is apparent in this view of the Plankinton House lobby. He made extensive use of marble and carved wood, and on the second-floor level the decor was topped off with numerous pieces of stained glass embellished with the letters PH.

The Majestic Building, located on the south side of Wisconsin Avenue between Second and Third Streets, was designed by Kirchhoff & Rose in 1907-08. The porcelain-like finish of the white glazed brick and terra-cotta made this building a focal point of the west side. Its 2000-seat vaudeville theatre was the best in the city; Sarah Bernhardt appeared here in 1912 and Milwaukeeans were astounded at her nightly performance fee of one thousand dollars in gold. The Merrill Building, designed in the late 1880's by architects Van Ryn, Andre, and Lesser is at the left edge of this view.

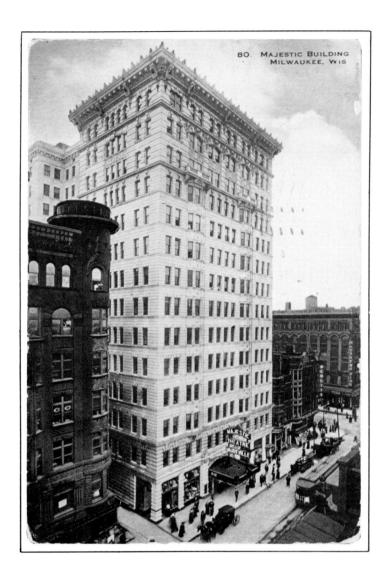

Another white-glazed terra-cotta structure was the Enterprise Building, built with Schlitz Brewery fortune money on the corner of Second and Michigan Streets. This beaux-arts design building was built in 1908 and was levelled in 1981 to make way for the parking structure adjacent to the Grand Avenue Mall project. The entrance arch with the inscription "Enterprise" was saved and dismantled by the author.

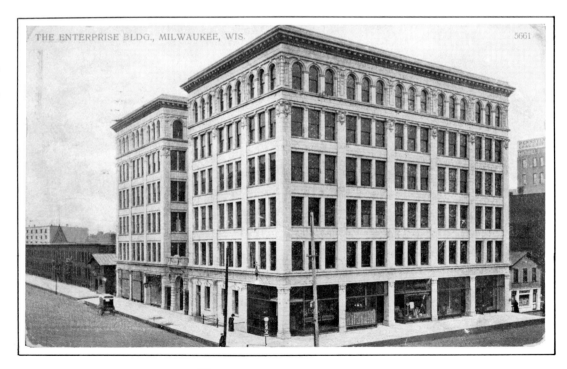

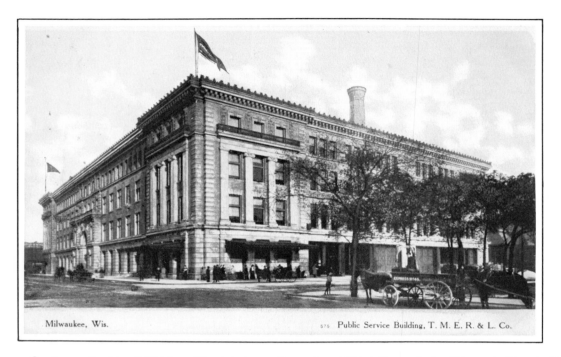

Milwaukee, Wis. 575 Public Service Building, T. M. E. R. & L. Co.

On the south side of Michigan Street, between Second and Third Streets is the Wisconsin Electric Company Building. Designed by Esser in 1903-5, it was the general office, central car house, and terminal station of The Milwaukee Electric Railway and Light Company. Stone carvings over the entrance depict a horse-drawn street car of 1890 and an electric car of 1905. Ironmaster Cyril Colnik fabricated the iron window and entrance plates as well as the many iron castings which support the numerous columns bases. Interesting architectural features abound — a fine leaded glass dome is located above the staircase, and doorknobs have depicted a clenched fist holding lightning bolts. In 1926 an additional floor was added to the building, not seen here.

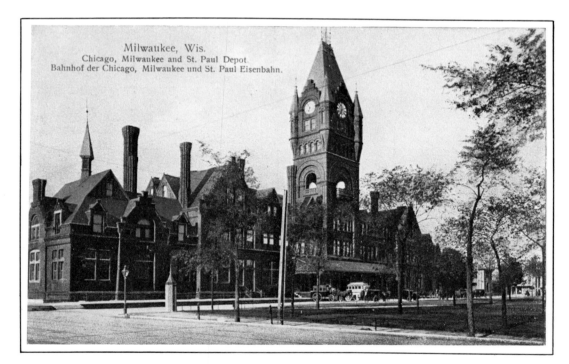

Milwaukee, Wis.
Chicago, Milwaukee and St. Paul Depot.
Bahnhof der Chicago, Milwaukee und St. Paul Eisenbahn.

This masterpiece by architect E. T. Mix was designed in 1884, and many consider the Bahnhof der Chicago, Milwaukee und St. Paul Eisenbahn to be one of the most picturesque in the country. Constructed of red brick and terra cotta, this building seemed to be something right out of a German fairy tale. In the late 1940's the tower was cut down and other ornamental features were removed in a misguided attempt to "modernize" the structure. With declining rail traffic and decreasing revenues the depot was dealt its final blow and was demolished in 1965. For the next twenty years this site remained vacant before it became the location for the expansion of the electric company.

One of the most magnificent passenger trains ever to operate in America was the "Hiawatha," which entered service between Chicago and Minneapolis-St. Paul in 1935 with streamlined cars and steam power. Speeds of 100 miles per hour were met on some parts of the route in order to make the advertised schedules, and because of the popularity of the train, the name was extended to an entire series of runs within the Chicago, Milwaukee, St. Paul and Pacific Railroad's system. The "Hiawathas" were money makers for the company for a number of years.

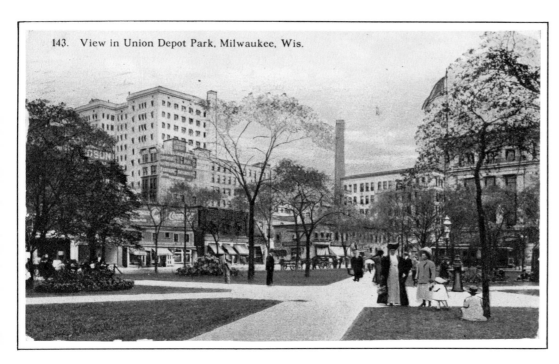

143. View in Union Depot Park, Milwaukee, Wis.

This pleasant spot between Third and Fourth Streets, south of Michigan Street, was first known as Fourth Ward Square, then Union Square Park, Park Place, Pere Marquette Park and finally Ziedler Park. Mr. Carl Ziedler, who was mayor of the city in 1940, gave his life fighting in World War II. His brother Frank was mayor from 1948 to 1960, and was the last of a string of Socialist mayors of Milwaukee. Emil Seidel was the nation's first Socialist mayor when he was elected in Milwaukee in 1910.

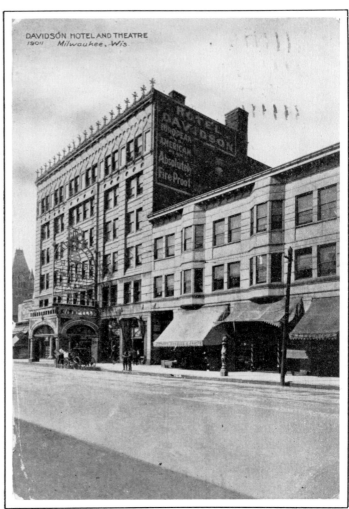

The Davidson Hotel and Theatre was located at 625 N. Third Street; designed by Burnham & Root in 1890, it was a unique style for Milwaukee. A disastrous fire occured in 1894, but damaged sections were rebuilt with the theatre continuing in business until 1954, when the 1200 seat house closed. The tower of the Chicago, Milwaukee, St. Paul and Pacific Railroad depot is visible at the extreme left of the view.

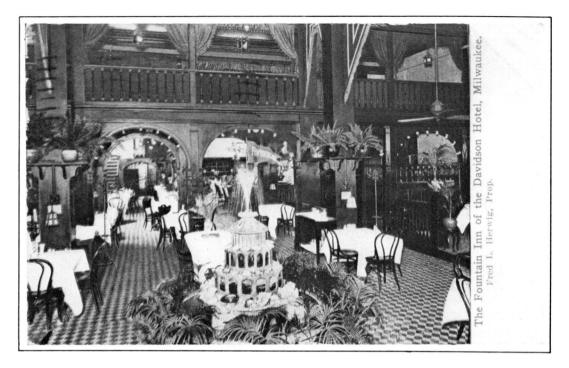

The picturesque fountain in the foreground and the potted palms and ferns made the Fountain **Room** restaurant of the Davidson Hotel a pleasant place to dine. Note the Casablanca-type fans that were so common in pre-air-conditioning times. They would have been equipped with direct current motors since most of the city was supplied with DC electrical energy in that early era.

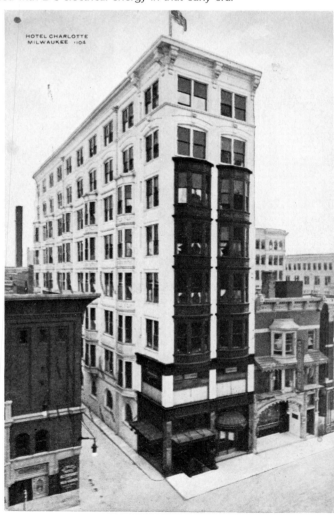

The Hotel Charlotte was another of the many small hostelries which operated in Milwaukee at the turn of the century. The Milwaukee Railroad depot was only two blocks away and while rail traffic flourished these hotels did a thriving business, but by the mid 1960's most of these places were just memories. To the immediate right and behind the three-story building on the street, the Enterprise Building is visible; it was on the corner of Second and Michigan Streets, and the Electric Company building, as seen in earlier views, is to its right. On the left of this view is the Schlitz Palm Garden.

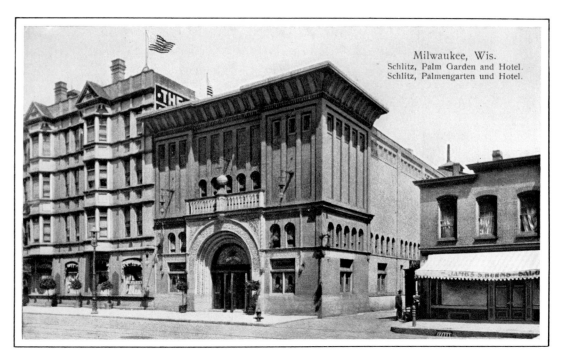

The Schlitz Palm Garden located on Third Street was one of Milwaukee's most famous saloons. Built in 1896 and designed by Kirchhoff & Rose, it closely resembled some of the works of the famed architect Louis Sullivan. Rich terra-cotta ornaments adorned its exterior, and the famous Schlitz globe with an encircling ribbon, their trademark, is seen above the railing over the entrance. The Schlitz Brewery operated many "company" saloons, in a manner which is traditional in "Pubs" in Great Britain to this day. At the left is the Schlitz Hotel which was built in the late 1880's; the 1870's building at the right was replaced by the Hotel Charlotte seen in the previous view.

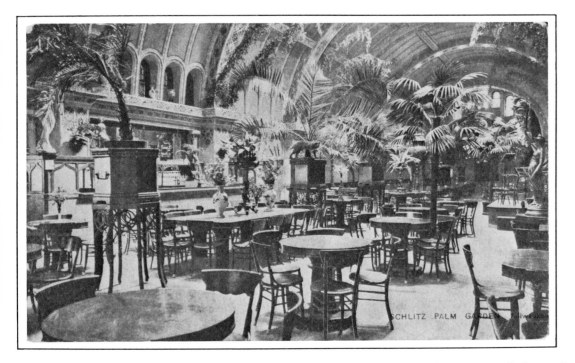

With this marvelously-cluttered interior, is it any wonder that the Schlitz Palm Garden was called one of the most beautiful saloons in the country? Potted palms were everywhere; statuary and objets d'art abounded, and there was a magnificent fireplace flanked by heavily jeweled and leaded stained glass windows. Rows of light bulbs illuminated the multitude of ceiling arches, under which it surely must have been a pleasant experience to pull back one of the oak chairs and sit down for a cool glass of Schlitz — "The Beer That Made Milwaukee Famous." On the average, seventeen barrels were consumed here daily, and on holidays it was not uncommon for thirty-five to forty to be tapped. Seating capacity was 900 and on many evenings, red coated 'live' musicians provided the musical backdrop. A WurliTzer Model CX coin-operated orchestrion with colorful stained glass was always at the ready to pound out toe-tapping melodies at other hours. Prohibition silenced all of this activity in 1919.

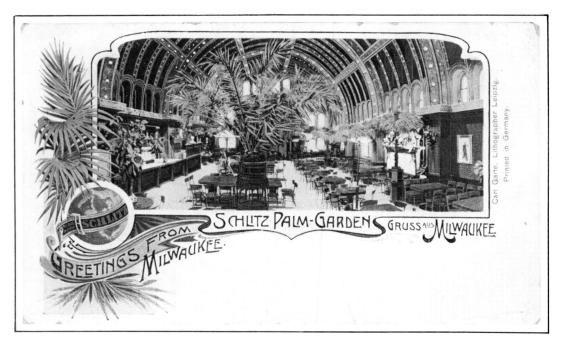

With the advent of Prohibition, the beer hall days were over as America went "dry." In 1921 the Schlitz Palm Garden was converted into the Garden Theatre with a seating capacity of 1200. The WurliTzer orchestrion was set aside and a two-manual, five-rank WurliTzer theatre organ was installed to accompany the silent movies. Over the years the name was changed; it was also known as the "Newsreel," and finally the "Little Theatre" before it closed for good in 1955. Silence prevailed where sounds of merriment once reigned, and after an eight-year wait the crash of the wrecker's ball sounded the death knell of this fine old hall. Note the Schlitz trademark on the card. Many post cards were produced by German lithographers before World War I, and are highly regarded by postcard collectors today for their fine quality. The printer's name appears on the right edge of the card. The artist who designed the cover of this book used the lettering from this card as a basis of his work.

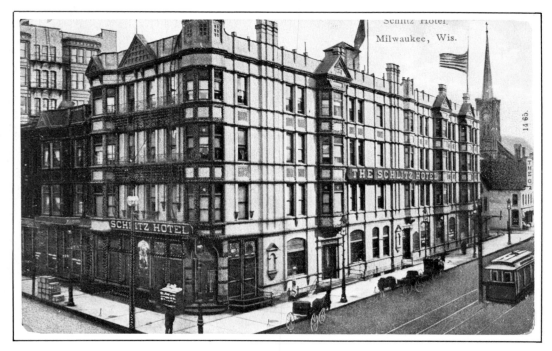

Here's the Schlitz Hotel in all of its glory. Constructed in 1887 of Milwaukee Cream City brick, it had 100 rooms, and finely finished parlors and reading rooms. Early advertisements noted that the hotel was lighted with electricity throughout. The Majestic Building was to replace the buildings at the left of the hotel shortly after the turn of the century. The Free Congregational Church built in 1862 is visible at the right; the Electric Company building replaced it in 1903.

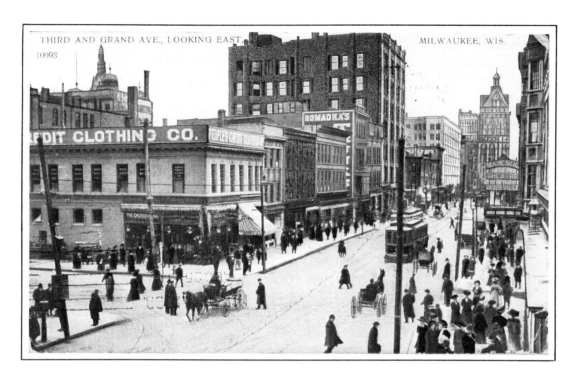

Automobiles were few and far between on Third and Grand Avenue — and everywhere else in Milwaukee — when this view was photographed in 1909. The top of the Germania Building can be seen at the left, with the large stone office building owned by the Plankinton family at the center, almost one block east. The Pabst Building is visible above the advertising sign of the Majestic Theatre marquee on the right.

The 1870's building located to the left of the Plankinton Office Building depicted in the center of the previous card was leveled to make way for this impressive 'nickelodeon' theatre which opened in 1911. (The term comes from the Greek 'odeon' for theatre, the admission to which was five cents, or a nickel). Named the Butterfly Theatre after its prominent architectural feature, it attracted many theatre patrons until it closed in 1930. Its stained glass and multi-hued facade was further enhanced by electrical lighting to create a magnificent effect at night.

Showing at the time this picture was taken was "The Early Life of David Copperfield," released by the Thanhouser Film Company of New Rochelle, New York, on October 17, 1911. Thanhouser, which released films from 1910 through 1917, was one of the best-known early film makers. Edwin Thanhouser, owner of the firm, earlier operated the Academy of Music theatre in Milwaukee from 1898 to 1906. Under his administration the theatre, which had earlier lapsed into hard times, prospered greatly and in the process earned him a fortune.

Even though the Butterfly's days of glory ended, a great movie palace arose on its site in 1931. Billed as Milwaukee's most costly movie palace, 2 1/2 million dollars were used to erect it in spite of the great depression which was gripping the country. Designed by the famed theatre architects Rapp & Rapp, this 2300-seat theatre is breathtaking to behold; the Art Deco lobby is one of the finest in the country. Originally opened as the Warner Theatre, it became known as the Center and finally as the Grand Theatre. Located at 212 W. Wisconsin, it continues to operate today, and almost all of its original splendor remains in spite of a 'twinning' (making two theatres from one) that was done in 1974. Film and architecture buffs fervently hope that this great temple of the movies and Milwaukee's last great such palace will be preserved to be enjoyed by future generations.

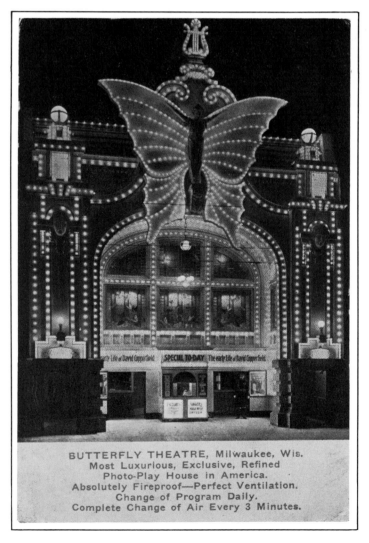

BUTTERFLY THEATRE, Milwaukee, Wis.
Most Luxurious, Exclusive, Refined
Photo-Play House in America.
Absolutely Fireproof—Perfect Ventilation.
Change of Program Daily.
Complete Change of Air Every 3 Minutes.

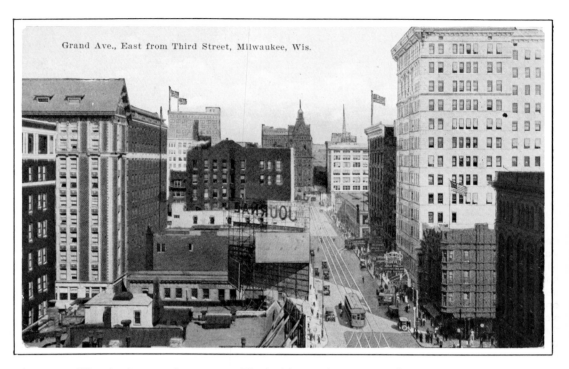

Grand Ave., East from Third Street, Milwaukee, Wis.

The west side of the river was known as Milwaukee's entertainment area. The building at the extreme left is the Miller Theatre and Hotel; it was designed by Wolff and Ewens, opened in 1917, and the 1700-seat theatre closed in 1979. Next to it is the Wisconsin Hotel. Billboards abounded throughout the city; note the back side of the one promoting the Milwaukee Journal in the center of this view. The present-day "Grand Mall" is now located on the right of this view. All of these buildings, with the exception of the Schlitz Hotel, still stand.

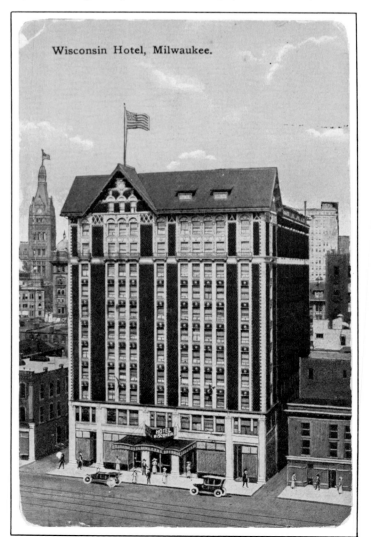

Wisconsin Hotel, Milwaukee.

The Wisconsin Hotel at 720 N. Third Street was built in 1912-13 to designs of the Chicago architectural firm of Holabird and Roche. Its dark-red brick provides a stunning contrast with the white brick and buff terra cotta trim, and the copper and tile roof is an unusual feature. With its 500 rooms, it was one of Milwaukee's larger hotels at the time of its construction, and it is still in business. Note the tower of City Hall at the left.

Third Street was the great theatre area of the city, and two are seen here — the American at 724 N., and two doors away at 738 N. was the Grand. The American, with the arched marquee, was designed by Kirchhoff & Rose with a seating capacity of 700, and it operated from 1910 to 1924. The Grand opened in 1904, was remodeled in 1910 and renamed the Princess, and continued to operate until 1984 when it was demolished. Through all those years the interior had changed little; the 900 seats were still the original ones affixed to the old wooden flooring. Six other theatres operated on this block at various times dur-

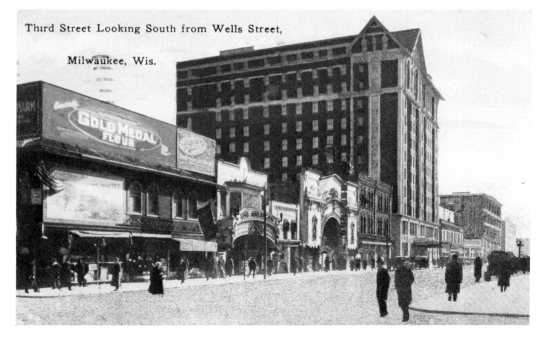

Third Street Looking South from Wells Street, Milwaukee, Wis.

ing the teens and twenties: The Crystal at 726 N. from 1903 to 1929; the Saxe at 755, the Miller at 717, the Vaudette at 735 (from 1908 to 1923), as well as the White House — also known as the Mid City, and the Atlantic which ran shows from 1916 to 1955. The Orpheum, also known as the New Star and Empress was located at 755 N. After the public turned its attention to television, the downtown movie business fell apart and today not one theatre can be found on this street.

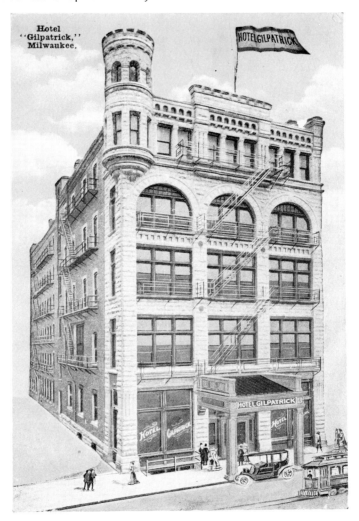

Hotel "Gilpatrick," Milwaukee.

The Hotel Gilpatrick was on the 831 N. Third Street site now occupied by the Hyatt Regency, and it stood from the late 1880's until 1941. A national tragedy almost occurred here, for President Theodore Roosevelt came close to being killed on October 14, 1912. He had dined at the hotel, and as he was leaving was struck by an assassin's bullet in the right side of his chest. Roosevelt refused medical attention and continued on to give a speech at the auditorium which lasted over an hour, after which the doctors removed the bullet which was partially stopped by the prepared speech in his vest pocket. Note the elaborate fire-escape apparatus, and the people, a car and the trolley on the street that have been added by a none-too-capable artist.

Many a fine German dish has been served at this nationally known and surely Milwaukee's most famous restaurant — Mader's, at 1037 N. Third Street. Many United States Presidents have dined here, and folks consider it one of the best places in the city to sample Milwaukee's "Old World" flavor. This postal card song was available in the 1920's. Across the street is the Usinger Sausage Company which was established in 1880, and to which no visit to the city can be considered complete without a sampling of their wares. It's a paradise for the gourmet sausage lover.

The Joseph Schlitz Brewery at 235 W. Galena Street, and the Pabst Brewery complex were the largest of the Milwaukee beer makers. August Krug started this firm in 1849, with his father and August Uihlein joining him the following year. August Krug died in 1856, and his widow married the bookkeeper, Joseph Schlitz, shortly thereafter. Joseph Schlitz died in 1875, and the Uihlein family has maintained control of the business ever since. The Milwaukee plant was closed in 1980, and as this is written, the remaining buildings are undergoing redevelopment as an office and shopping center complex. All of the structures were constructed of cream colored brick, with many of the buildings trimmed with elaborate terra-cotta panels. The tower at the extreme left of the view still stands, but most of the buildings to the rear of the view have been demolished.

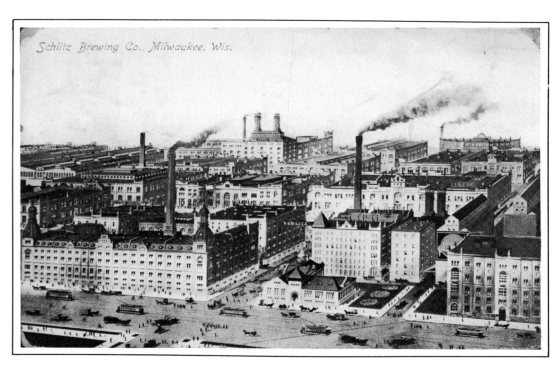

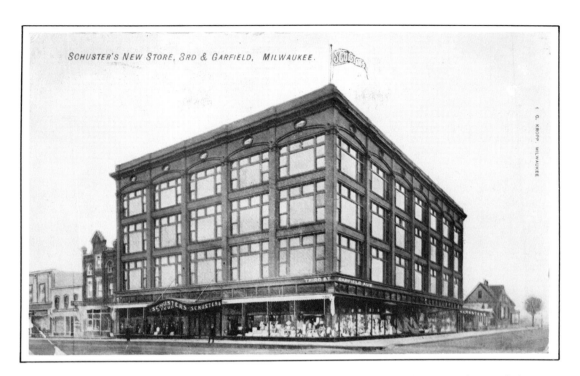

This familiar Milwaukee landmark is three blocks north of the Schlitz Brewery. Schuster's operated several department stores in the Milwaukee area until the late 1950's when they were bought out by the Gimbel department store chain. In the 1920's the upper Third Street shopping area was a thriving business district, but as years progressed much of the section fell into decay though fortunately many of the original buildings from as far back as the 1870's remain. The area, now known as "Brewer's Hill" is beginning to be reborn with many exciting restoration developments taking place.

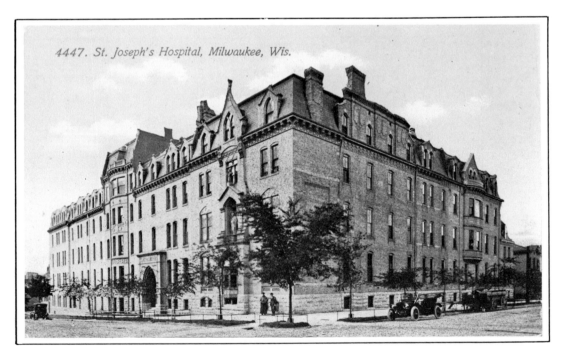

St. Joseph's Hospital stood at Reservoir and North Fourth Street for almost one hundred years before it was demolished; it was built in the late 1870's. This bluff area overlooking the city has many of the oldest and most architecturally interesting houses, churches, and commercial buildings in the community.

The Milwaukee Exposition Building was designed by Edward T. Mix with 400 feet between Fifth and Sixth Streets, and a 293 foot frontage on State Street. The height to the top of the cupola was 200 feet; there was a large water fountain within the structure, and it was the first public building in the city to be equipped with electric lighting. The Milwaukee Museum specimens were located on the first floor, and a large aquarium was in the basement, together with the Milwaukee Fish Hatchery. At one time 8000 carp, 9,000,000 wall-eyed pike, 2,000,000 rainbow trout and 70,000 black bass could be found here. The

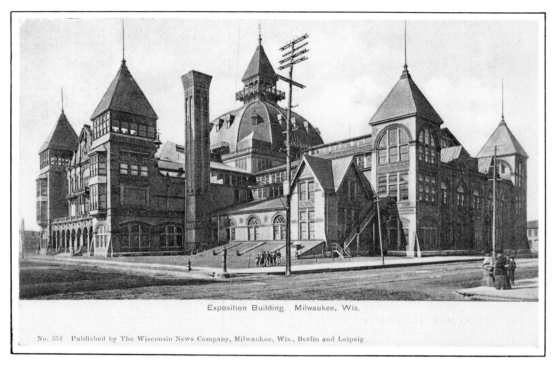

Exposition Building. Milwaukee, Wis.

No. 354 Published by The Wisconsin News Company, Milwaukee, Wis., Berlin and Leipzig

Hastings and Hook pipe organ with 2894 pipes divided into fifty-one ranks was the building's most impressive feature; it was unsurpassed in volume as well as in tone by any other concert organ west of New York City at the time of its installation. The building was opened in 1881, but by 1887 the Exposition Center needed money so the organ was sold to Immanuel Presbyterian Church which had just lost its organ to a disasterous fire. This move proved most fortunate as the Exposition Center burned to the ground in 1905. The instrument survives to the present day, with only minor modifications having been made over the years.

THE NEW AUDITORIUM, MILWAUKEE,

WISCONSIN TEACHERS ASSOCIATION
Annual Meeting--Milwaukee, Nov. 4, 5, 6, '09.

New Auditorium Building.

Headquarters

Sectional Meetings

Bureau of Information
Educational Exhibits
Social Reunions
WE NEED YOU.

Voting Booths
Free Check Room
Cafe in Basement

J. A. Hagemann, Treasurer
Ft. Atkinson

John Kelley, President
Juneau

Katherine Williams, Secretary
Milwaukee

COPYRIGHT 1908, BY E. C. KROPP CO. MILWAUKEE
SOLE PROPRIETORS OF POST CARD PRIVILEGE.

The present Milwaukee Auditorium, built at 500-590 W. Kilbourn in 1907-09 to designs of Ferry & Clas, replaced the Exposition Hall which had been destroyed by fire. Opened to the public on 21 September, 1909, this fine facility boasted many halls and exhibit areas. Its 1100-seat Plankinton Hall contained a fine E. M. Skinner pipe organ with a roll-playing attachment which your author rescued when it was sold for scrap in 1977. This two-manual, fifteen rank instrument is the second oldest surviving Skinner instrument in the country, and as all organ buffs recognize, Mr. Skinner made instruments of the very finest quality in all respects so it is especially gratifying to know that it survives to entertain future generations. This card is especially interesting for it promotes the first Teacher's Convention to be held in this new facility; they have been held here ever since.

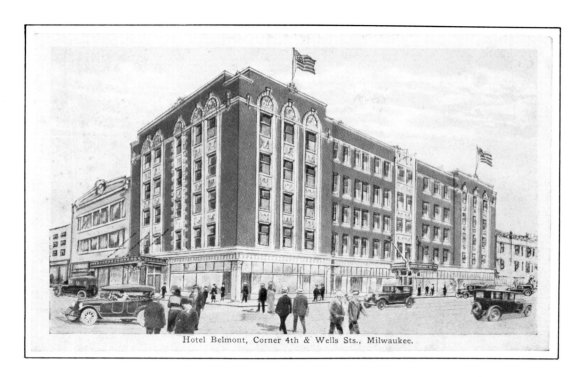

Hotel Belmont, Corner 4th & Wells Sts., Milwaukee.

The Belmont Hotel is one of the last of numerous small hotels which once abounded in Milwaukee. Those who study its features on the corner of Fourth and Wells will find many fine terra-cotta details of interest, and especially the lion faces found on the trim pieces. The Art-Deco-inspired hotel sign is the finest remaining one of its type from the 1930's left in the city.

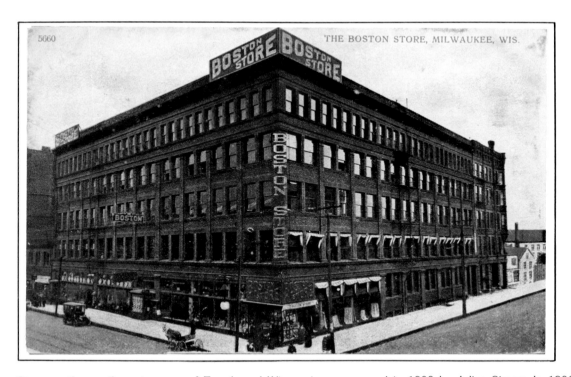

5660 THE BOSTON STORE, MILWAUKEE, WIS.

The Boston Store on the south east corner of Fourth and Wisconsin was opened in 1900 by Julius Simon. In 1906 two partner tenants, Carl Herzfeld and Nat Stone, organized the present store form and their venture grew and eventually evolved into six branch stores. Though now covered by a layer of paint, much of the original building survives and still serves as an outlet for fine merchandise.

Mechanical music buffs will be delighted to know that the Milwaukee Boston Store was the first prize winner for the best window display in a nation-wide contest during "National Player Piano Week," April 2-9, 1921. This was a promotional effort sponsored by the Standard Pneumatic Action Company of New York City, makers of player mechanisms which were used by a large number of piano manufacturers across America. The decade of the 1920's was the heyday of the player piano, once an important entertainment device in private homes everywhere as well as in public places; 1923 was the year of the highest production of these instruments which quickly thereafter became victims of the new and advancing popularity of the phonograph and the radio.

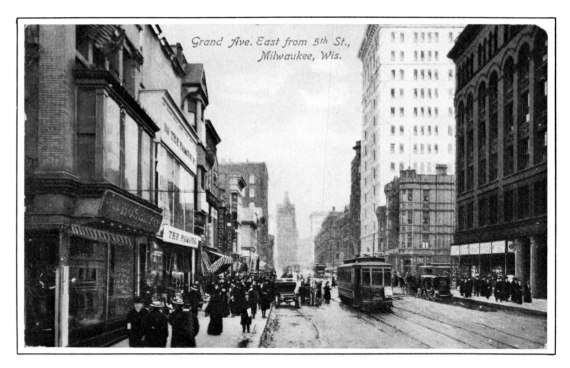

This view is from Fourth Street, and not Fifth as the card states. The Gargoyle Restaurant, (its vertical sign is seen on the left), was one of Milwaukee's finest eating establishments from 1904 until 1921 when it was remodeled into the 834-seat Rialto Theatre. The large white building on the right is the Majestic Building, with the Schlitz Hotel on this side of it. The building with the arches at the right was constructed in 1892 to designs of Ferry & Clas for the Matthews Brothers, an architectural woodwork company known nationally for its fine wood products; the woodwork in the House of Representatives chamber in Washington D. C. is one of their commissions. This fine building at 301 W. Wisconsin has many interesting buff terra- cotta details embedded in its orange-brown pressed brick, and today it flanks the new entrance to the Grand Avenue retail mall complex. From restaurants and shops on the third floor one can get a nice close-up sight of these details as this addition was built right into the side of the facade of the Matthews Building. Although the Matthews firm is no longer in business, the "M" initial can still be found on the terra-cotta moldings on the facade.

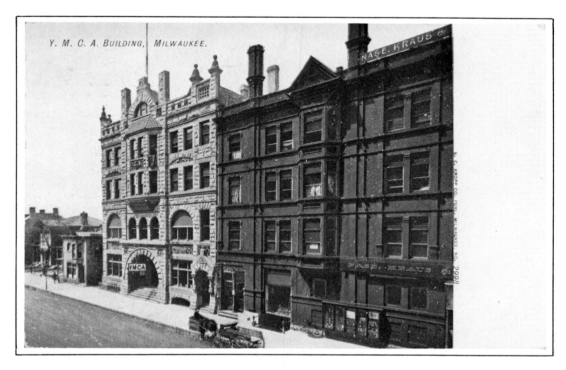

The Young Men's Christian Association was founded in Milwaukee on September 29, 1858, and architect E. T. Mix designed this stone Richardson Romanesque structure to house the YMCA and its activities. It was opened on January 1, 1887, and was located on the west side of Fourth Street between Wisconsin and Michigan Streets, where today the Boston Store parking facility is located. The Italianate houses from the 1860's that appear in this view verify that this was once a residential area. The building at the right was replaced by the Randolph Hotel.

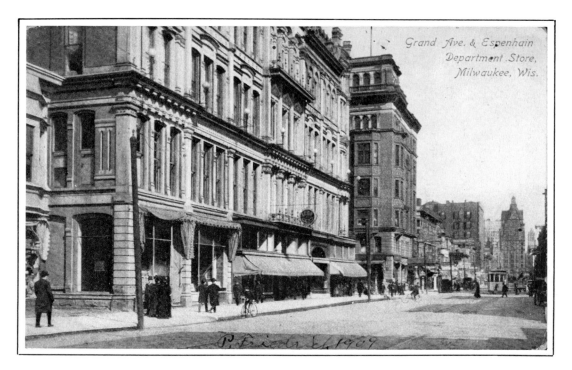

Espenhain's Department Store was one of the larger Milwaukee mercantile establishments in the latter part of the nineteenth century. The building with the flag pole is the Alhambra Theatre and office building, located at 334 W. Wisconsin. This 2500-seat performance facility whose music hall was patterned after the European continental style operated from 1896 until it was demolished in 1960. Patrons of its three bars were served products of the Miller Brewery.

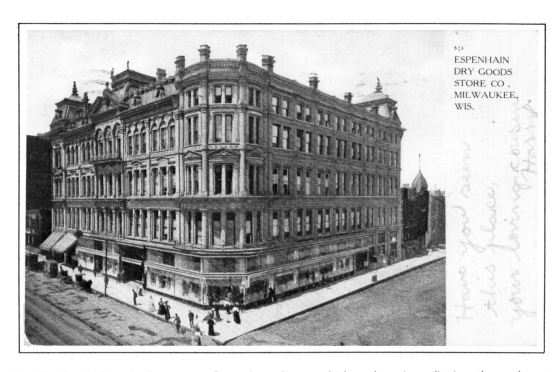

Here's a full view of the Espenhain Dry Goods Store (or Department Store, depending on which card one is reading) on the northwest corner of Wisconsin and Fourth Streets. This impressive building was one of the city's most ornate Victorian commercial buildings when it was constructed in 1880 on the site of Byron Kilbourn's mansion which had been erected in 1853. The Milwaukee Library was one of the early tenants, prompting the building to be called "The Library Block." The Espenhaim business continued for a little over fifty years until the Great Depression forced it, and others like it, to close its doors. The building was demolished in 1935.

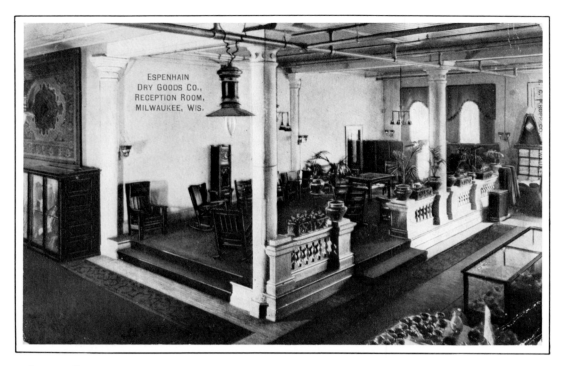

A trip to Espenhain's was always a delight, according to Gretchen Colnik. What store today would have a reception room? Elegance of this kind no longer exists, at least for most shoppers. Pianists were on hand in the music department to play the latest song sensations for prospective purchasers of sheet music. The store carried a full line of household goods in addition to clothing and the usual wares of a dry goods establishment. Note the arc light fixture in the foreground.

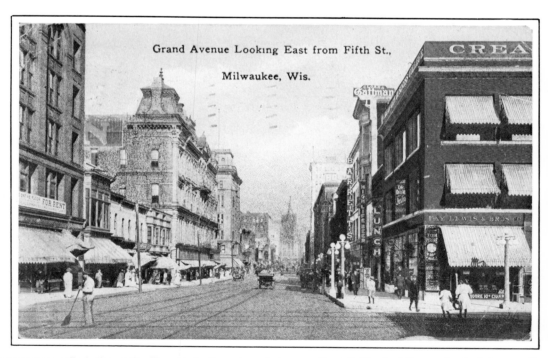

Grand Avenue Looking East from Fifth St.,

Milwaukee, Wis.

Wisconsin Avenue, as this street is now called, shows the Espenhain Department store on the left. The building at the far left, partially visible, still stands but most of the buildings on the right in this view were demolished in the mid 1980's and at this writing this block is a parking lot.

The Schroeder Hotel at 509 W. Wisconsin, the site of the Methodist Episcopal Church built in 1867, was designed by the Chicago architectural firm of Holabird and Roche in 1927. Today it's known as the Marc Plaza; it has 550 guest rooms and rises 25 stories above the avenue. Potowatomi Indians had their village here in the early 1800's where today's travelers now spend the night.

HOTEL · SCHROEDER · MILWAUKEE · WIS.

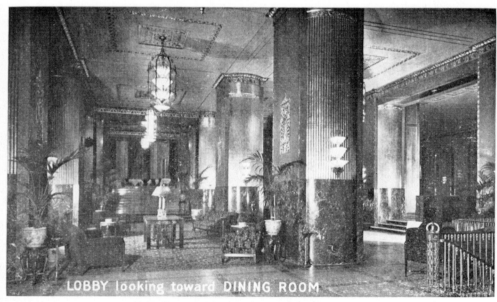

LOBBY looking toward DINING ROOM

THE LOBBY, HOTEL SCHROEDER, MILWAUKEE, WIS.

Art Deco design was the new trend when the Schroeder Hotel was built, and in this view a fine display of fixtures, railings, and wall treatments of this style are apparent. The interior has not been drastically altered and many of these fine details can still be seen. The exterior features several carved stone panels set in the limestone walls. and the base of the building is faced with pink and black polished granite, two very popular colors in the "new" Deco style.

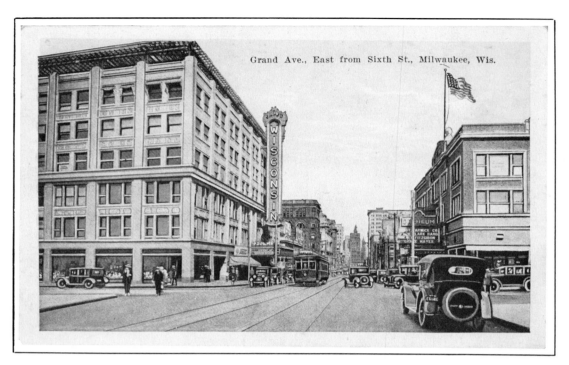

Grand Ave., East from Sixth St., Milwaukee, Wis.

One block further west on Wisconsin Avenue is this view on Sixth Street. The Wisconsin Theatre at 530 W. Wisconsin was designed by the famed Rapp and Rapp firm, and it was a large house with seating capacity for 3275. The lobby was stunning with its two-story columns and sweeping staircase, replicating a French palace. The Wisconsin sign was seventy-five feet high and when lit it could be seen for miles. Milwaukeeans were literally ushered (by a crew of well-uniformed ushers who assisted them to their seats) into the "Movie Palace Era" when this million-dollar house opened on March 28 of 1924. The building featured a ballroom for dancing on the top floor. In later years the theatre was "twinned" with an escalator running through the lobby, thus destroying much of the original effect. The building was leveled in 1986, and at this writing the address is a vacant lot. Another fine theatre across the street was the Orpheum, (later, the Palace) designed by Kirchhoff & Rose in 1915, and with 2437 seats was Milwaukee's first large movie house. The theatre was demolished in 1974, but the front as seen here remained.

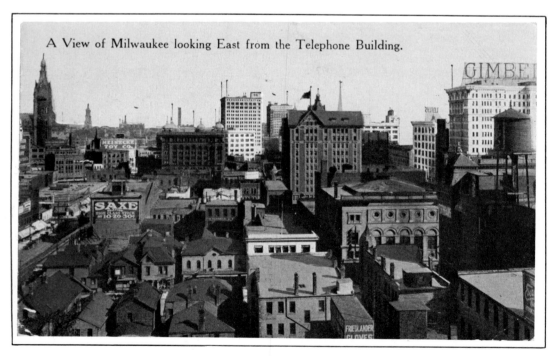

A View of Milwaukee looking East from the Telephone Building.

This view shows much of the west-side commercial development of the city. The Telephone Building, from where the photo was taken, was designed by the prominent local architect A. C. Eschweiler, and the stone carvings he specified for the exterior featuring a Bell motif may still be observed even though the building is used by the Time Insurance Company. A few residences from the 1870's are apparent in the foreground, and they were displaced by the commercial developments of the 1920's. It would appear that the publisher of this card had his artist fudge the big Gimbel roof-top sign in the wrong place, as it's on the Majestic Theatre building, and not the proper white building which is about an inch further to the left.

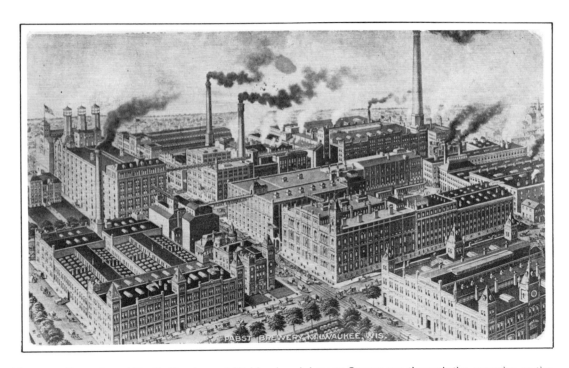

The Pabst Brewery is located between Seventh and Tenth Streets, and Highland and Juneau Streets run through the complex as the east-west streets. Founded in 1844 by Jacob Best, it is Milwaukee's oldest operating brewery. In 1889 the name was changed from Best to Pabst. When this turn-of-the-century view was made, the establishment had the distinction of being the largest brewery in the world, thus helping to establish Milwaukee's reputation as the world's beer capital. Many of these buildings with their crenelated walls were designed by Otto Strack, and are constructed of cream-colored brick so characteristic of the city. Quite a few still stand, and with the remaining cobblestone streets, have a European charm seldom found in American cities.

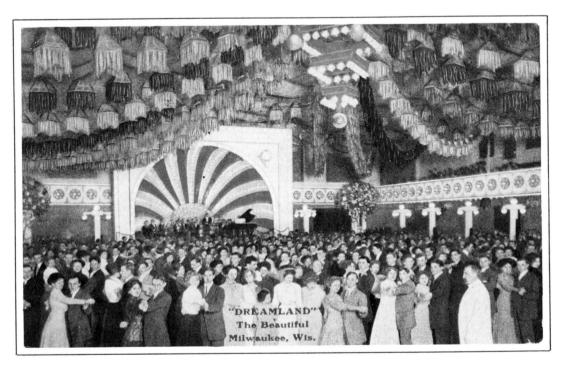

Dreamland opened at 622 Wells Street in 1911 with Andrew G. Wirth as manager. This fine ballroom and dancing academy was short lived and closed in 1919. Wirth operated the Palace Dancing Academy in 1920 at 149 Sixth Street; it closed the following year. In 1921 Dreamland became the Fountain-Lipman automobile dealership.

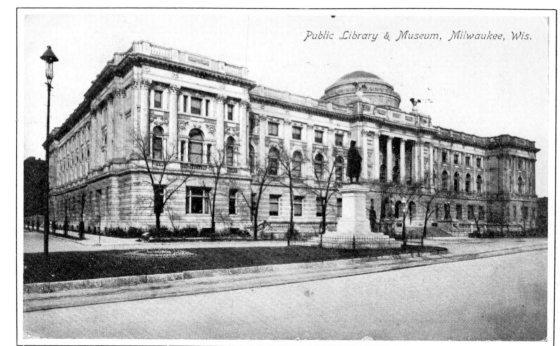

Public Library & Museum, Milwaukee, Wis.

The Public Library and Museum Building at 814 W. Wisconsin Avenue was designed by Ferry & Clas, and opened in 1898. The Italian Renaissance Revival building is constructed of Indiana Bedford limestone. Elaborate carvings which were completed on the site adorn the walls and columns of this fine building. Two outstanding light standards of ornamental bronze stand beside the entrance, and two carved stone eagles with bronze wings flank the big center dome. Inside, some of the finest mosaic tile floors to be found in the country are in the hallways and the rotunda; tile setters came from Italy to do this work and then settled here. Outstanding marble, plaster, and bronze work is found throughout the building, and fine woodwork and panelled walls are abundant.

On December 8, 1847, a meeting was held to organize the city's first library, and from 1848 to 1898 the book collection was housed in various locations around the city. At the turn of the century, 180,000 volumes could be found here. Peter Engelmann acquired a large collection of natural history specimens, many of which were housed at the German English Academy he founded, and they eventually were incorporated into the museum which was created by a legislative act in 1882. Its permanent home was for years a 38,000-square-foot- area in the building, but in the middle years of the twentieth century a new museum facility was built one block north on Wells Street, so the library is now the sole occupant of this building. Milwaukee's museum is considered by many to be among the finest in the United States.

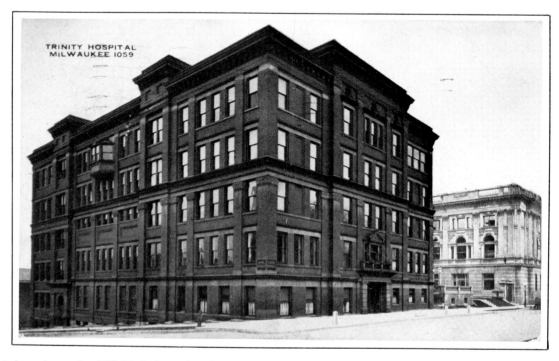

Trinity Hospital was located at 200 Ninth Street (southeast corner of Ninth and Wells today), having opened shortly after the turn of the century. It became the Marquette University Hospital in 1923, and served in that and other medical capacities until it was razed in 1931. The site was eventually used for expansion of the present library when a new addition was completed in 1956. A portion of the rear of the library/museum building is visible.

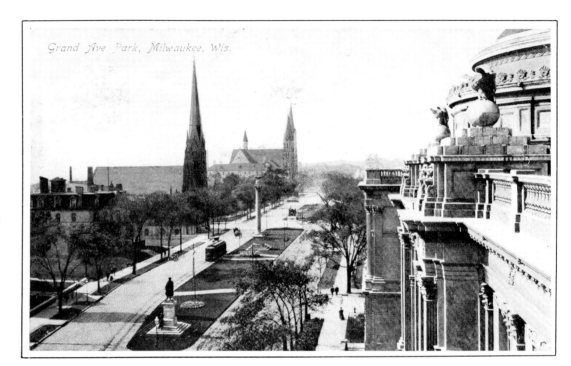

Looking west from the roof of the Library/Museum Building (note the two eagles) on Grand (Wisconsin) Avenue. The church with the tall thin spire is Calvary Presbyterian which was built in 1870, designed by H. C. Koch. Its cream city brick today has a coat of red paint. There was concern among some that the spindly tower might topple in a strong wind, so the architect proved to the skeptics that it was structurally sound by having a team of horses tug at it with a long rope. It's now well into its 2nd century of successfully dealing with mother nature's worst elements; apparently he knew what he was doing. A serious fire in 1947 destroyed some of the fine Gothic-style interior, but many of the geometric stained glass windows survived. The spire in the distance is Gesu Church. The sixty-five foot column in the boulevard was designed by Alfred Clas and was constructed in 1900 for the carnival of that year. It still stands.

The Presbyterians are credited with being the first to build a church in this city. On April 11, 1837, Reverend Ordway presided at a meeting at the court house where plans were prepared to establish a congregation. Reverend Gilbert Crawford of New York State was chosen to begin the ministry that July, and the first church was built on the corner of Second and Wells Street that same month. A few years later they moved to Milwaukee and Mason Streets where the still- standing Colby Abbot Block was later built in 1881. In 1870 the West Side Presbyterians founded Calvary Church shown here; they split from the East Siders who went on to build Immanuel Presbyterian shown earlier in this work.

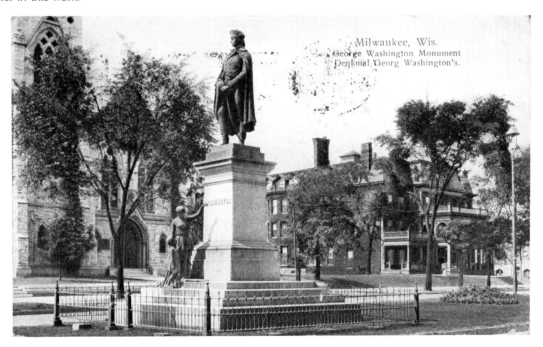

The George Washington Monument at Ninth and Wisconsin was the city's first monument. It was designed by the Florentine sculptor R. H. Park and was given to the city by Elizabeth Plankinton in 1885. St. James Episcopal Church at 833 W. Wisconsin is in the left background; it was the city's first all-stone church, designed by E. T. Mix in 1867, stands essentially unchanged today. The building at the right is the four-story Hotel Aberdeen, erected in 1878 by James Kneeland. In 1880 it was enlarged to 90 rooms, and it remained in business until 1954 when it was demolished to make way for the new YMCA. James Kneeland was a contractor and real estate developer of early Milwaukee and he owned the parcel between Eighth and Eleventh and Wisconsin and Clybourn Streets which held his mansion, coach house, grove, and private lake. The lake pond became Red Arrow Park depicted in that view.

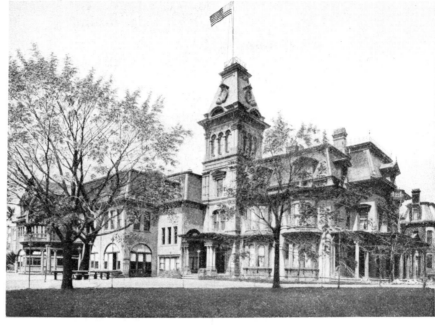

Directly across the street on the north side at 900 W. Wisconsin is the Wisconsin Club, formerly the Alexander Mitchell mansion. The original structure which dates back to 1855 was obscured by the work of E. T. Mix when he remodeled the home in 1870. The section to the left of the tower was built in 1895 when the mansion was acquired by the Deutscher Club, known today as the Wisconsin Club. This addition was built on the site of the 500-foot-long greenhouse, the largest in the state. Mitchell was a prominent early financier and developer in Milwaukee; his Mitchell Block is depicted earlier in these pages. His grandson Billy Mitchell was a general officer in the U. S. Army Air Service who after World War I was an outspoken advocate for development of air power — so outspoken, in fact, that he was court-martialled for insubordination. Many of his theories were validated when our country became involved in World War II, with the result that he became a national hero retroactively. One superb military aircraft, the North American B-25, was named for him, as was Milwaukee's airport.

Not only is this residence one of the most outstanding Second French Empire style buildings to be found anywhere, but also of great architectural interest is the gazebo on the front lawn. With its scroll-cut ornaments and etched glass, it is perhaps the finest suriving gazebo in the country. The initials "A. M." are carved in the exterior panels. The interior walls are adorned with English encaustic tiles, and the original painted and gold-leaf ceiling survives.

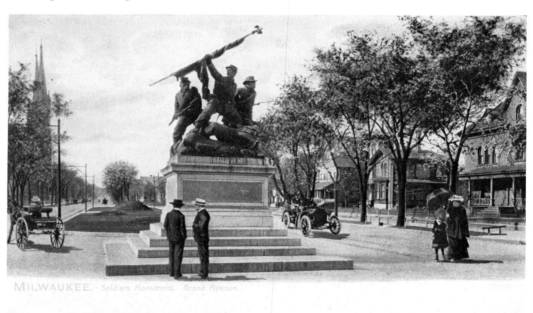

MILWAUKEE. Soldiers Monument. Grand Avenue.

The most significant of the monuments on the "Court of Honor" between Ninth and Tenth Streets on Wisconsin Avenue honors the Civil War Veterans. Executed by John S. Conway, it was cast in Rome in 1898. In 1880 the statue was proposed and Alexander Mitchell offered to pay for it, but he died in 1887, whereupon his son prepared to follow through with the project. Unfortunately, the financial panic of 1893 ruined him, and the project came to a temporary halt. A Mrs. Ely acquired blank United States currency paper and put together a book in which she sold spaces to famous people (like Clara Barton of American Red Cross fame) for their autographs and messages. Fred Pabst, owner of the brewery, offered to pick up the balance of the monument's cost if he could have this autograph book; it is now in the Milwaukee Public Library. The houses at the right were torn down for future development shortly after 1910.

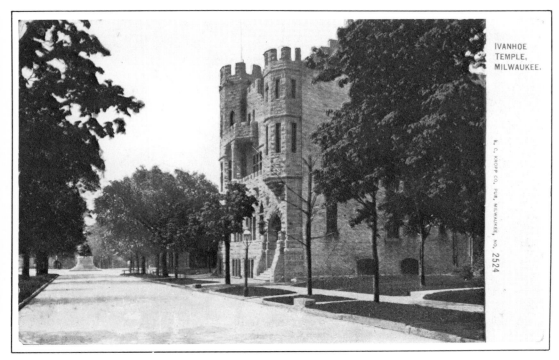

Ivanhoe Temple at 723 N. Tenth Street had the distinction of being the only German Masonic Lodge in Wisconsin. Note the civil war monument in the background where Tenth Street ends at Wisconsin Avenue; the present-day expressway eliminated this street, and the statue was moved further east. The Masonic movement began in Milwaukee with about 40 or 50 masons who first met at the Cottage Inn on July 5, 1843; this Masonic Lodge received its charter in October of 1890. When the Ivanhoe Lodge was built, it was considered one of the most beautiful in the west. By the turn of the century, 350 lodges of various fraternal organizations existed in the city, giving Milwaukee the distinction of having more than any other community of comparable size. Ivanhoe Temple was demolished in 1968 for the construction of the present freeway system.

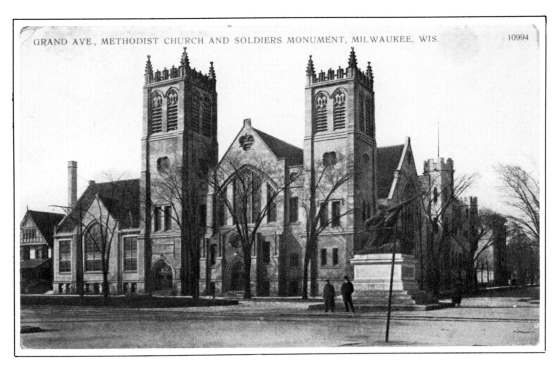

Grand Avenue Methodist Church stood at the northwest corner of Tenth and Wisconsin. The houses depicted in the prior photograph behind the Civil War Monument were demolished and in 1907 this church was built. It stood until the 1960's when construction of the expressway required its removal; the congregation merged with the congregation at Wisconsin and Twenty-fifth streets.

The previous location of this congregation had been at Fifth and Grand (Wisconsin) in the church which was dedicated on October 8 of 1871. The continued expansion of the commercial district had forced the move further west to Tenth Street.

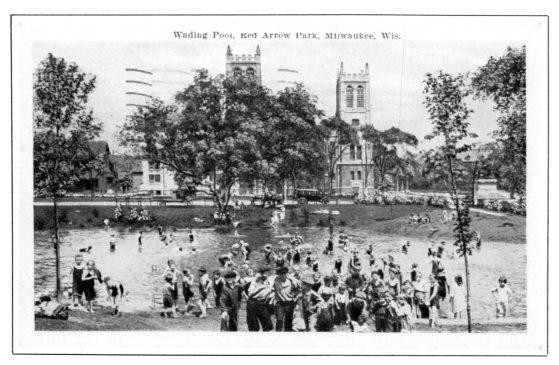

Wading Pool, Red Arrow Park, Milwaukee, Wis.

The expressway ended this summertime scene. In this rare view we see the swimming pond in Red Arrow Park, Wisconsin and Tenth Streets. James Kneeland's mansion stood at this spot in the 1870's, and before that, the Wisconsin State Fair was held here from 1852 to 1861, in the area between Tenth and Thirteenth Streets. In 1859 Abraham Lincoln was hired to speak at the fair for what some considered an outrageous sum of $100. He gave his speech from a hay wagon and after he concluded, an enterprising showman asked Lincoln to step into his side show. One of his attendants promptly placed a sign on the front of the tent — "Meet Lincoln 10 cents." This area became the Milwaukee Pacifist Center where soap-box orators could speak without fear of intimidation, as at the famed Hyde Park corner in London, England.

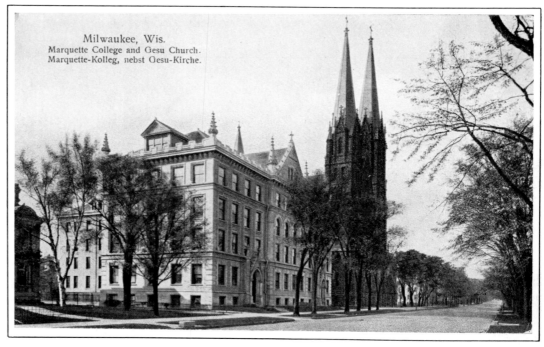

Milwaukee, Wis.
Marquette College and Gesu Church.
Marquette-Kolleg, nebst Gesu-Kirche.

Marquette University, a Jesuit institution, was founded by Bishop Henni in 1848 but was not formally recognized by the state as an educational institution until it was granted a charter in 1864. Its tenure as a University started in 1881. Johnson Hall is a Venetian Gothic-style building at 1131 W. Wisconsin Avenue; it was built in 1906-07. GesuChurch at 1145 W. Wisconsin is an 1893 French Gothic design from the drawing board of H. C. Koch; he had it built of gray limestone, and fitted with a magnificent rose window. The altar contains a sculptured Pietacarved by Giovanni Dupre of Sienna, Italy, his only work in the USA.

The oldest building in Wisconsin, by virtue of having been imported, is the 15th-century Joan of Arc Chapel from the French village of Chasse. In 1927 the crumbling remains were brought to Long Island by the daughter of railroad magnate James J. Hill. Disassembled and rebuilt on the Marquette Campus in 1964, it contains a stone which is cooler than its surroundings because, it is said, Joan of Arc's blood fell upon it when she was burned at the stake.

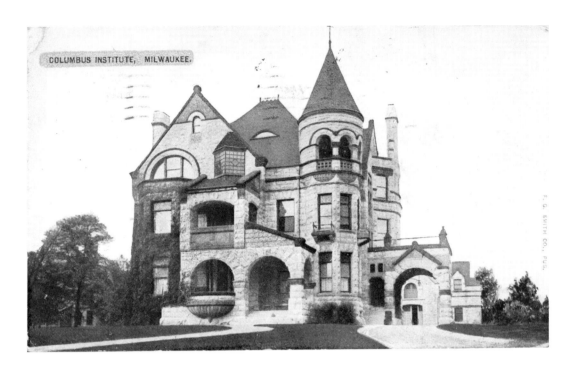

The Plankinton family amassed a large fortune through real estate dealings and the meat packing business. Three magnificent family mansions stood on this block. John was the patriarch of the clan, and his home, the most costly residence in the state when it was built, was destroyed in 1975. His brother William's home was demolished in 1968. This Richardson Romanesque structure which fell to the wrecker's ball in 1980 was constructed in 1887 for John Plankinton's daughter Elizabeth as a wedding present. Her fiancé ran off with another woman and Elizabeth is said to have walked into the building and then left, never to occupy this fine residence. The mansion stood vacant at 1492 W. Wisconsin Avenue until 1910 when the Knights of Columbus began an occupancy which continued until 1978.

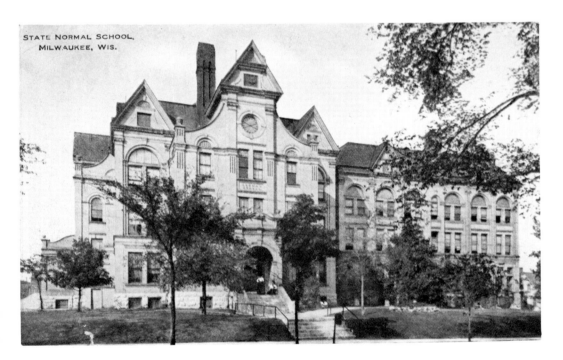

Architect E. T. Mix designed this fine building at 1820 W. Wells Street in 1885. In 1880 the state legislature passed a law establishing a normal school in Milwaukee, to be erected at a cost of at least $50,000. This red and yellow brick building came close to that, costing $52,000. Mr. J. J. Mapel was the first president, with 46 students in the Normal Department and 112 enrolled in the model school during the first year of operation. The annual budget appropriation was $10,000. The section at the right was added in 1894, and other additions to the west or the rear of the building were added in 1918 and 1932. The building eventually became part of the Milwaukee Public School System and was known as the Wells Street Junior High until it closed in 1978. For almost ten years, the building stood vacant before it became the Milwaukee Rescue Mission headquarters.

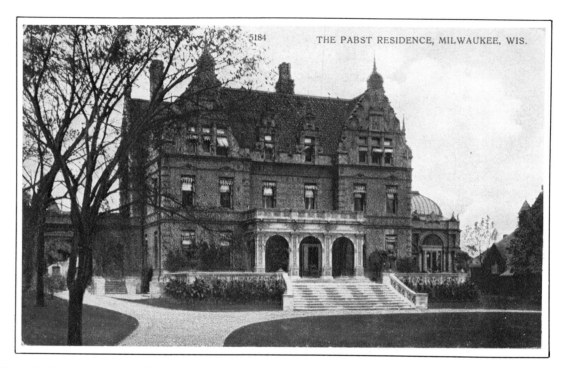

THE PABST RESIDENCE, MILWAUKEE, WIS.

Architects Ferry & Clas designed this fine home, constructed in The Flemish Renaissance style, between 1890 and 1893, for beer baron Frederick Pabst. In 1906 when it became the residence of the Archbishop of Milwaukee. The interior boasts exceptional woodwork; of special interest is a section of panelling that was brought over from a German castle and installed in the library. The pavilion to the right of the mansion was designed by Otto Strack and constructed of terra-cotta. Assembled at the 1893 Columbian Exposition in Chicago as a display pavilion for the Pabst brewery, it was brought to this spot when the fair was over. Under the aegis of the archbishop, it became a chapel. In 1976 the mansion was sold to a motel chain with the prospect of becoming another parking lot, and the carriage house behind the building was demolished. Fortunately for the preservation minded, a number of local citizens rallied behind a a successful effort to save this one, and at this writing, it is open to visitors throughout the year.

ARCH BISHOP MESSMER
RESIDENCE
MILWAUKEE 1132

In this unusual view we can see why Grand Avenue was called "grand": it was the street where the rich and elite of the city resided. The Pabst mansion (by this time residence of the Archbishop) is set back from the street, and ironically, the building visible at the left is the facility of the Little Sisters of the Poor, at Twentieth and Wells Street. It was designed by H. C. Koch in 1877, and was demolished in 1977.

98

Reverend William Passavant came to Milwaukee in 1863 with only two one-dollar gold pieces to his name, so he had to work hard to make his dream of building a hospital a reality. Backers were found, and they started the institution in a rented farmhouse, thus establishing the first Protestant hospital west of Pittsburgh. A fire in 1883 destroyed that building, following which the one seen here was erected in 1884 at 2200 W. Cedar Street (Kilbourn). In 1912 a six-story buff brick addition was built; a west wing was added in 1927 and in 1932 the east wing was completed, obliterating this old section. The ornamental fence survives. This part of Milwaukee became the city's hospital district.

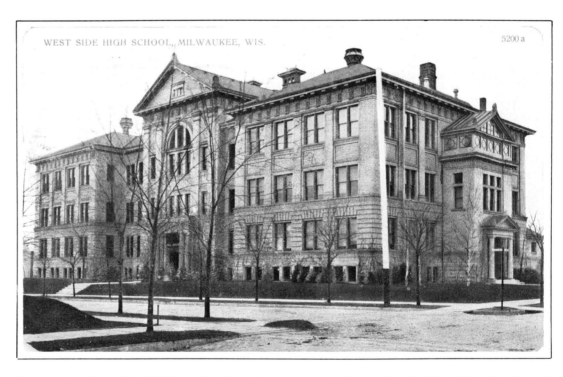

Growth of the city necessitated more schools, and in 1893 the school board passed a resolution creating the West Side High School. Classes were first held in the Plankinton Library Block downtown; they moved to this structure when it was completed in 1895. Located at Twenty-third and Prairie (now Highland), it remained in operation until 1957 when it was demolished to make way for a more modern building. General Douglas MacArthur attended this school in 1898.

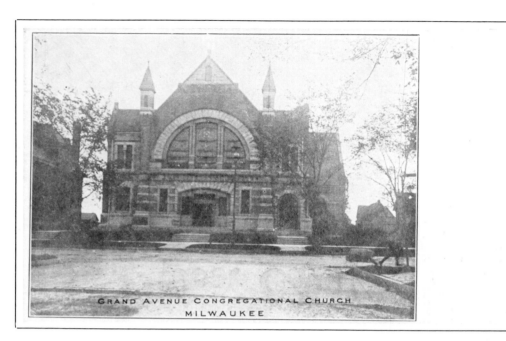

GRAND AVENUE CONGREGATIONAL CHURCH
MILWAUKEE

E. T. Mix designed this Richardson Romanesque church at 2133 W. Wisconsin in 1887 and this was one of his very last commissions, for he died in 1890. It is constructed of cream colored brick trimmed with limestone, and the interior, which seats 1300, is most unusual and well worth seeing. The history of the congregation dates back to 1847 when it was organized as a Free Congregational Church, strongly opposing slavery. The first meeting place was on Broadway between Mason and Wells (then Oneida); in 1852 they built a church at Second and Spring Street (which became Grand and finally Wisconsin Avenue), and in 1854 they moved further west to Sixth Street. The church still holds forth in this fine building, retaining the Grand Avenue name.

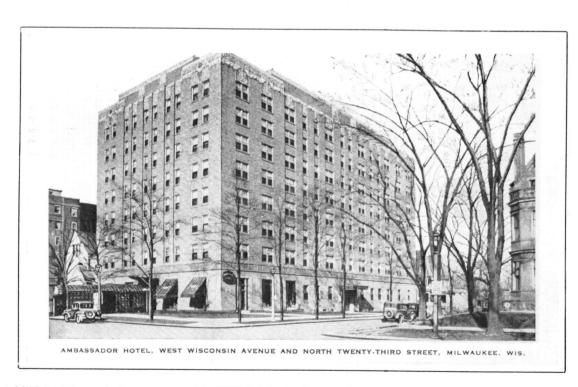

AMBASSADOR HOTEL, WEST WISCONSIN AVENUE AND NORTH TWENTY-THIRD STREET, MILWAUKEE, WIS.

The Ambassador Hotel at 2300 W. Wisconsin Avenue opened in 1927. It is built of orange-brown brick, trimmed with elaborate terra-cotta Mayan-influenced designs. Fine art deco decor graces the interior, including superbly worked bronze elevator doors and light fixtures in the lobby. It's considered such a pleasant place that some of the 189 guest rooms have been lifetime homes for guests. During the late 1920's and 1930's many big bands stayed here during their engagements at the Million Dollar Ballroom in the Eagles Club one block further west, and the Crystal Chandelier Room, now a restaurant, frequently hosted Friday and Saturday night dances.

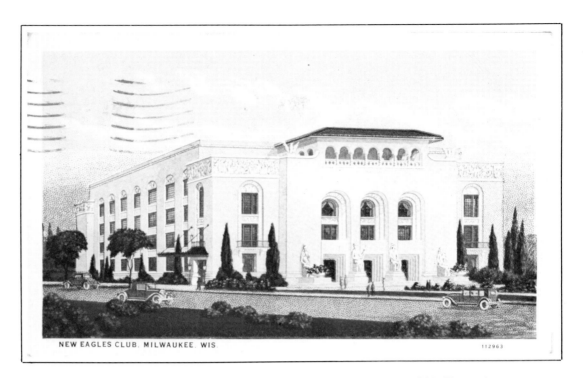

NEW EAGLES CLUB, MILWAUKEE, WIS.

112963

The Eagles Club at Twenty-fourth and Wisconsin was designed by architect Russel Bar Williamson in 1925. The architecture combines Spanish and Italian styles, with carved stone friezes along the roofline depicting scenes of importance to the Fraternal Order of Eagles. Many fine examples of Cyril Colnik's ornamental iron work in door hardware, light fixtures, and railings are found throughout the building. The most spectacular feature of the building is the "Million Dollar Ballroom" on the top floor. Decorative plaster work in this room is almost beyond belief, and must be seen to be appreciated. It is surely one of the finest ballrooms in the United States.

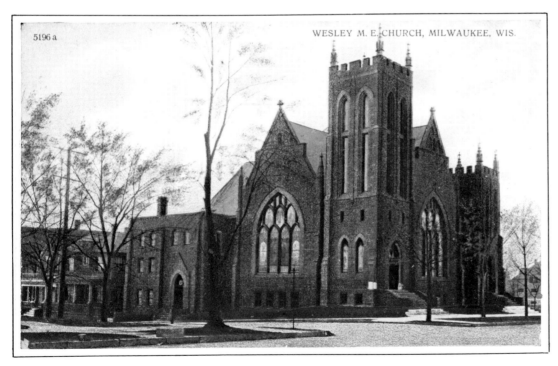

5196 a

WESLEY M. E. CHURCH, MILWAUKEE, WIS.

This red sandstone church at the corner of Twenty-fifth and Wisconsin Avenue was built in 1904; the Washington Avenue congregation moved here and changed the name to the Wesley Methodist Episcopal Church. Methodism can be traced back to 1835 in Milwaukee with the first church having been built on Broadway between Oneida (Wells) and Biddle (Kilbourn) Streets.

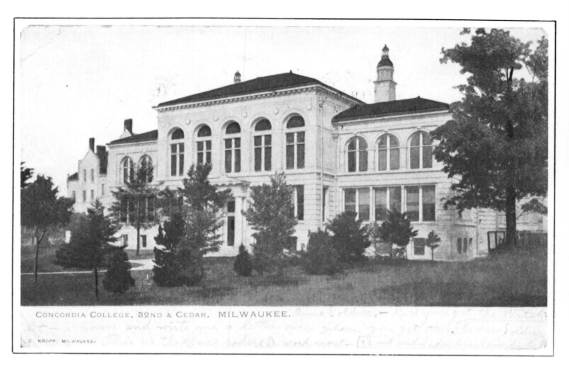

CONCORDIA COLLEGE, 32ND & CEDAR, MILWAUKEE.

The Evangelical Lutheran Synod of Missouri founded Concordia College in 1881, with the first classes being held at Trinity Church at Ninth and Prairie Streets. Land was soon purchased between State and Wells Streets and by 1883 the building seen at the far left was erected at a cost of $16,000. The main structure in this view was built in the late 1890's, and the school carried on here on Milwaukee's west side until the early 1980's when it relocated in the suburbs. At this writing the building with its beautifully detailed interior stands abandoned.

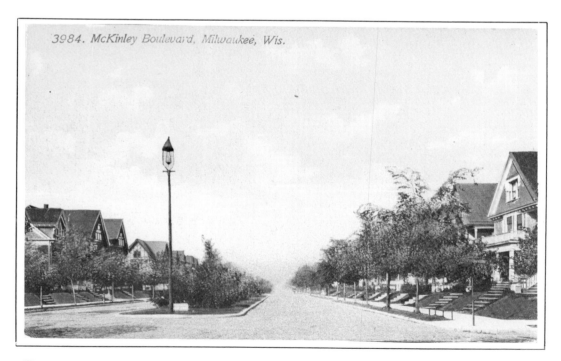

3984. McKinley Boulevard, Milwaukee, Wis.

This view is from Twenty-seventh Street looking west on McKinley Boulevard. The area from Juneau to Vliet Streets and from Twenty-seventh to Thirty-fifth Streets made up Coldspring Park, which had a horserace track as well as sufficient space to accommodate the Wisconsin State Fair from 1870 to 1891. After the turn of the century the area was developed as a residential section, and the many fine homes are much as they were close to five generations ago.

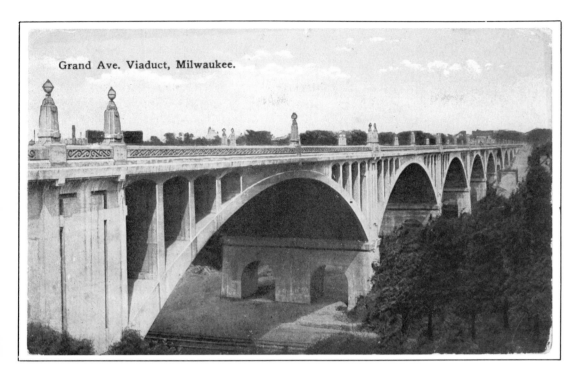

Grand Ave. Viaduct, Milwaukee.

The 2088-foot-long Grand Avenue Viaduct was constructed in 1907-1911 at a cost of over half a million dollars, and required half a million board feet of lumber to construct the forms for the concrete. The area that it spans was known as 'Pigsville', after a number of pig farms that were once located in the valley. As this book is being written, plans are under way to demolish this viaduct and replace it with a structure estimated to cost 14 million dollars.

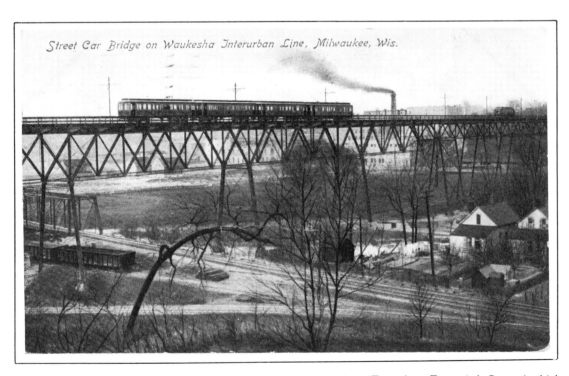

Street Car Bridge on Waukesha Interurban Line, Milwaukee, Wis.

The Street Car Bridge which was built in the late 1890's paralleled the Grand Avenue Viaduct (Fortieth to Forty-sixth Streets) which was built after this picture was taken. Those who have ridden a streetcar across this long bridge will confirm the fact that riders often wondered about their safety as the cars rocked from side to side while crossing the bridge 90 feet above the Menomonee River. Their worries stopped when trolley car service ended in 1958. The bridge was dismantled a few years later.

103

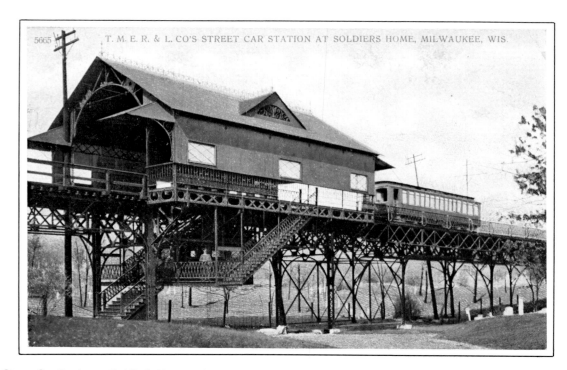

This is the Street Car Station at Soldier's Home. After crossing the bridge in the previous picture part of the line continued in a westerly direction while another section crossed through the area today occupied by the county stadium, to the south. The stadium site was a stone quarry which yielded much of the fine Wauwautosa limestone used to build many of the turn-of-the- century and earlier buildings throughout the city. This station was built shortly after the introduction of electric street car service to the city in 1890.

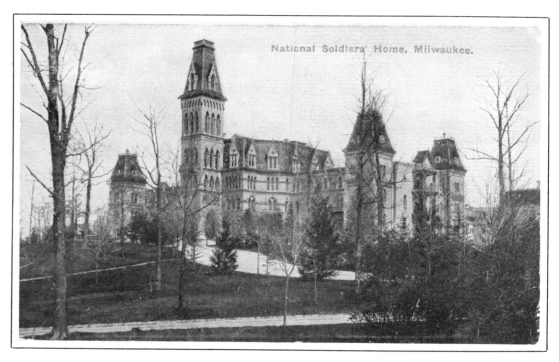

Matthew Keenan was the man principally responsible for acquisition of this site for a home for disabled and wounded veterans of the Civil War. It is located on Milwaukee's far west side in the Menomonee Valley at about Fiftieth Street. Edward Townsend Mix was chosen to design this project, and he created this most imposing Gothic-revival structure with its five-story tower in 1868. Situated on 400 acres of land with accomodations for 2500 veterans, this establishment was the first of its kind built by the Federal government. Many of its buildings, including the one seen here, still stand; the tower cuts a stunning silhouette against the skyline on the hill above the stadium.

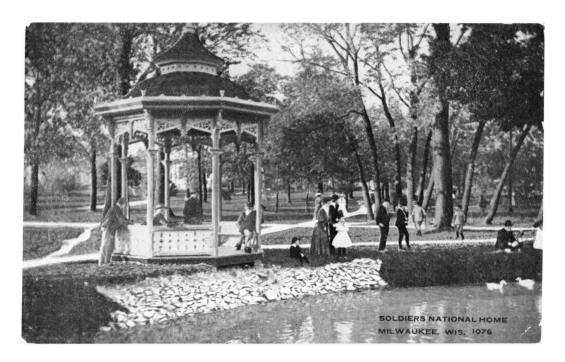

This Victorian gazebo was found adjacent to one of numerous ponds in the parks surrounding the Soldier's Home, and was the scene of many an afternoon concert.

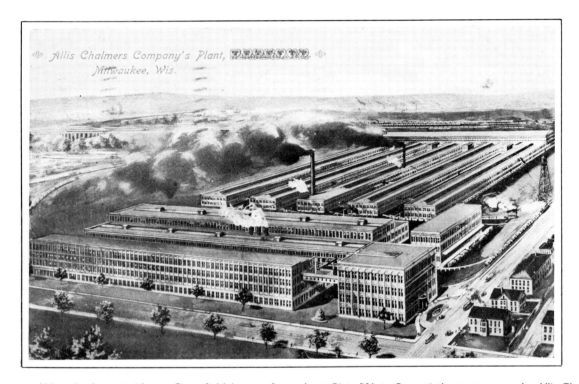

Farther west on Milwaukee's west side, on Greenfield Avenue from about Sixty-fifth to Seventieth streets, were the Allis Chalmers Company buildings, which once housed the largest heavy-machinery plant in the United States. E. P. Allis began the company in 1860 as a producer of flour mill machinery, and soon expanded into building steam engines and boilers to equip America's burgeoning post-Civil War industrial expansion. The 20,000 horsepower engine for the Brooklyn Surface Railway was one notable accomplishment of the firm. In 1892, 1800 employees worked here. At this writing, most of the buildings have been demolished or are standing empty, and a portion of the factory is being redeveloped as a shopping mall.

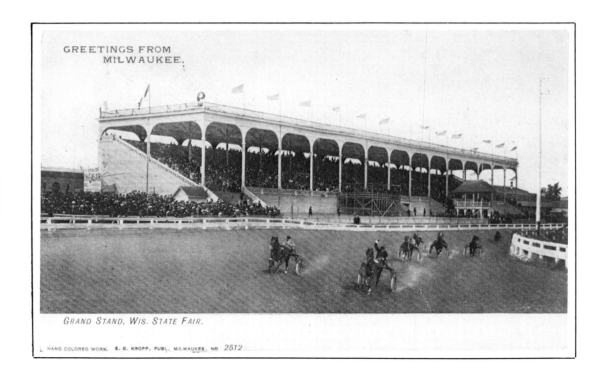

GREETINGS FROM MILWAUKEE.

GRAND STAND, WIS. STATE FAIR.

HAND COLORED WORK. E. C. KROPP. PUBL. MILWAUKEE. NO 2512

The Wisconsin State Fair moved from Coldspring Park on the west side to its present location, purchased in 1892, on land which once was the McFetridge farm. Many a harness race, as we see here, has been run on the track, and today stock car races are hosted as are music concerts during the fair's run of ten days in early August. The midway has featured many amusement rides including the roller coaster known as "Sky King," and a beautiful carousel built by the Philadelphia Toboggan Company once delighted visitors. During the 1960's the carousel was moved to Muskego Beach on the far west side and was subsequently sold. Most of the fairground buildings of an earlier day have been demolished and replaced by formless modern counterparts, and as late as 1963 twenty-five coin-operated pianos could not find homes and were pushed together in a pile and burned. Today little remains of the old days of the Wisconsin State Fair.

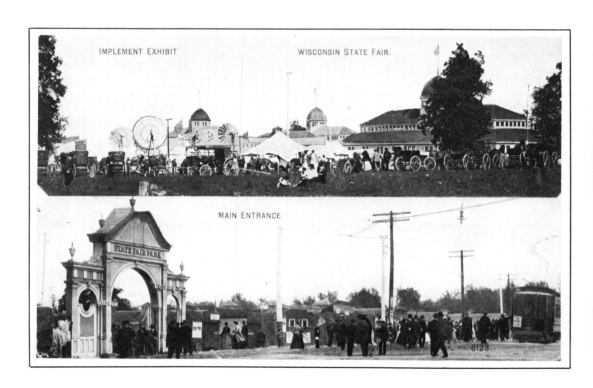

IMPLEMENT EXHIBIT WISCONSIN STATE FAIR.

MAIN ENTRANCE

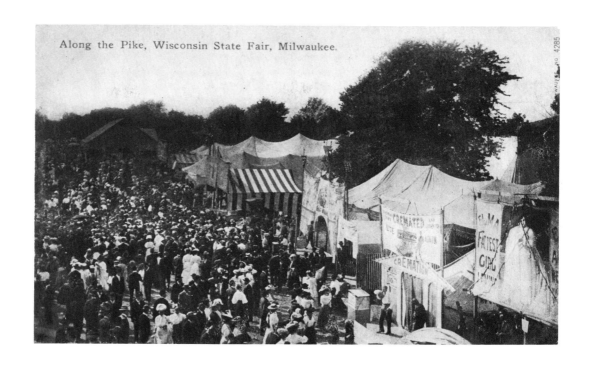

Along the Pike, Wisconsin State Fair, Milwaukee.

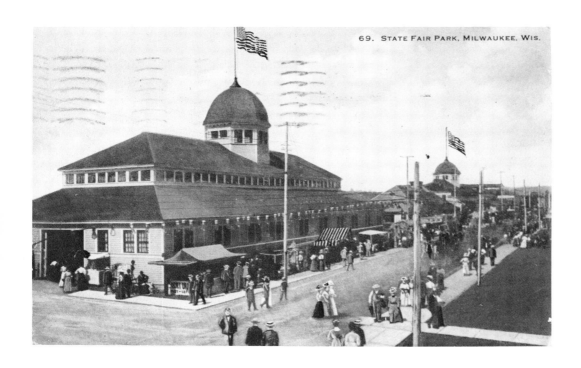

69. STATE FAIR PARK, MILWAUKEE, WIS.

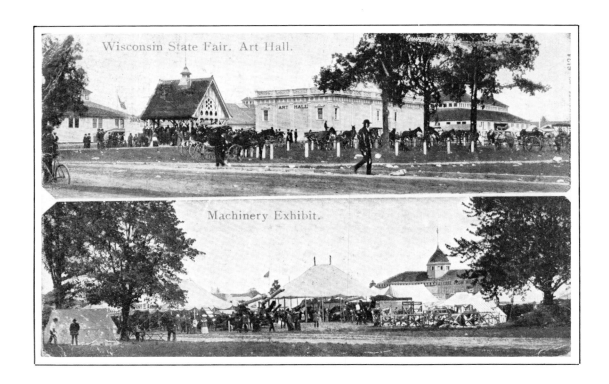

Wisconsin State Fair. Art Hall.

Machinery Exhibit.

115. River View from Boat House,
Washington Park, Milwaukee, Wis.

West Park shortly after the turn of the century became known as Washington Park. It ran from Vliet to Pabst Streets south and north, and Fortieth to Forty-seventh east to west. The last section was acquired by 1902 to bring the total area to 148 acres. Frederick Law Olmstead laid out the design for this park as well as Lake Park, and he included such pleasant features as this tranquil artificial lake. City planners of an earlier era were farsighted in the matter of parks; by 1907, 816 acres had been set aside for this purpose for the enjoyment of future generations.

120. Watching the Wild Animals
at Washington Park Zoo,
Milwaukee, Wis.

The Milwaukee Zoo opened in 1904 at Washington Park, and remained there until 1963 when it was relocated further west along Bluemound Avenue at approximately Ninetieth Street. Construction on the new zoo began in 1958 on 184 acres, and cost over 14 million dollars. It ranks among the finest of American zoological gardens, and features beautiful open environments for the animals instead of cages more typical of zoos in earlier times.

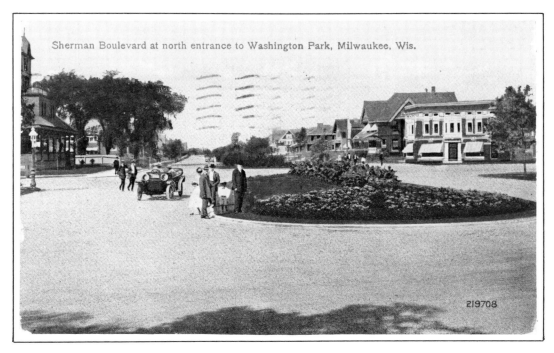

Sherman Boulevard at north entrance to Washington Park, Milwaukee, Wis.

219708

Sherman Boulevard was developed shortly after the turn of the century; beautiful landscaped plantings along these wide boulevards are still maintained to enhance this area of fine homes built between 1905 and 1925. The building at the right is of dark red brick trimmed with white glazed terra-cotta, and several snarling lions ornament the exterior. This view has changed little over the years. The building at the left was constructed around 1880, and was called the Steubenhof. Today the Boulevard Inn occupies this site.

109

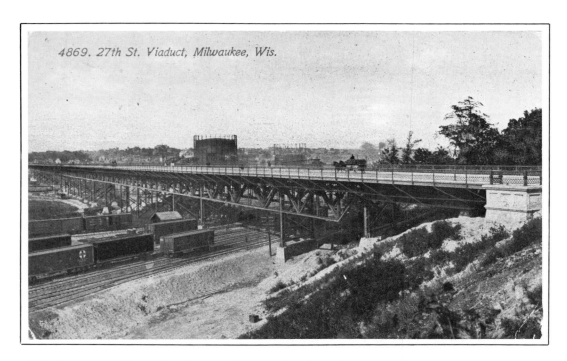

4869. 27th St. Viaduct, Milwaukee, Wis.

The Menomonee River valley is crossed by several viaducts; this one which carried Twenty-seventh Street was constructed in 1910 and has since been replaced. Note the large gas holders in the background. Historically, the valley separated Milwaukee's north and south sides but the viaducts linked them. Much of the area's rail traffic ran in the valley, minimizing the noise and clatter of the iron horse. The south side of the city was settled predominantly by Polish immigrants, and in these later years continues to have a large Polish population.

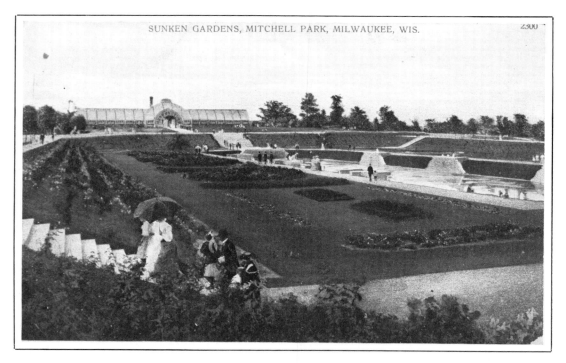

SUNKEN GARDENS, MITCHELL PARK, MILWAUKEE, WIS.

Immediately south after crossing the Twenty-seventh Street viaduct one finds Mitchell Park. In 1890 the city acquired twenty-five acres and shortly thereafter John L. Mitchell gave an additional five-acre adjoining tract to the city. In 1900 the city purchased an additional twenty-eight acres, bringing the total to fifty-eight. The greenhouse in this view were replaced in the 1960's with three geodesic domes, each of which is eighty-five-feet high and one-hundred-forty-feet in diameter; the facility is known as the Mitchell Park Horticultural Conservatory.

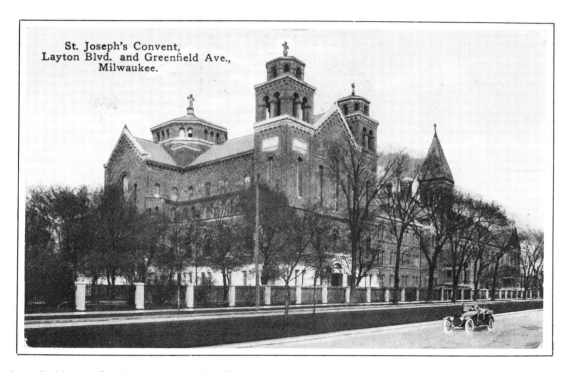

St. Joseph's Convent,
Layton Blvd. and Greenfield Ave.,
Milwaukee.

Twenty-seventh Street was also called Layton Boulevard, named after Frederick Layton of the Art Gallery. At 1501 S. Layton Boulevard stands St. Joseph's Convent. The church building, with Italian Lombard arcading, was designed by Richard Phillip and was constructed between 1914 and 1917.

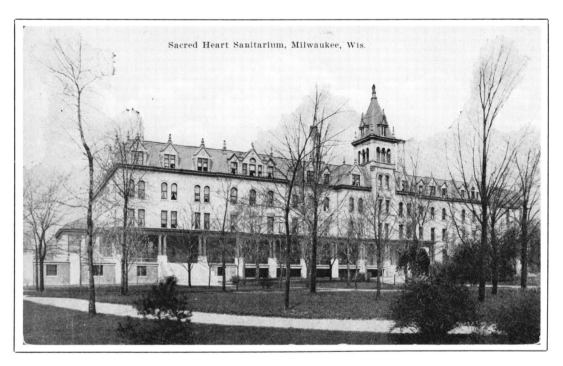

Sacred Heart Sanitarium, Milwaukee, Wis.

Immediately to the south of St. Joseph's is Sacred Heart Sanitarium which opened in 1893. This Romanesque and French-Gothic-inspired edifice stood until the late 1970's when it was replaced by a much less imposing but more practical low- level structure. The hospital has the distinction of being the first to be accredited for physical rehabilitation work in the United States.

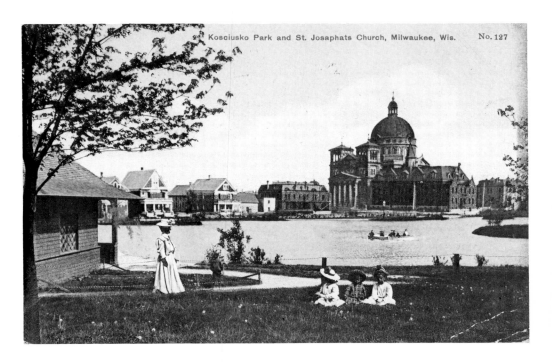

Kosciusko Park is located on the south side between Lincoln and Beecher Streets. Twenty-six acres were purchased in 1890 with the remaining eleven being acquired in 1902. With its picturesque lake, this scene of the St. Josaphat Basilica could lead viewers to believe that they had never left Europe.

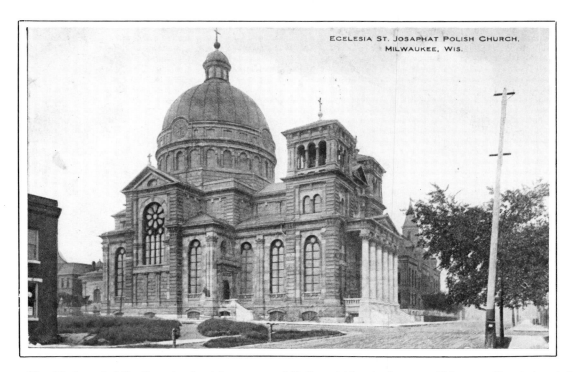

ECELESIA ST. JOSAPHAT POLISH CHURCH.
MILWAUKEE, WIS.

The St. Josephat Basilica stands at the corner of Sixth and Lincoln Avenues. This magnificent church benefited from a major early recycling effort by its parishioners, who purchased the salvage of the Federal Building and Post office in Chicago and moved the materials to Milwaukee on five hundred railroad flat cars. This Neo-Renaissance structure was designed to be built from these salvaged components by Erhard Breilmaier, and his dome is a facsimile of Rome's Basilica of St. Peter. Construction took five years and was carried out by members of the church, several of whom lost their lives during the project. Dedication ceremonies were held in 1901. The stunning interior with its magnificent ornamentation and stained glass is a sight to behold. Bronze door plates dating from the 1870's bear the United States Treasury Seal, attesting to this impressive salvage accomplishment — a true testimonial to the will and determination of the Polish people of Milwaukee.

This parish, the third oldest Polish parish in the United States, was organized in 1852, and active worship services began under the leadership of Father Bonaventure Buczynski in 1853. The church was designed in 1872 by architect Leonard Schmidtner; it is constructed of cream-colored brick trimmed with limestone. In 1962 it was remodeled, and it is interesting to compare this turn-of-the-century photograph with its present-day appearance.

The Milwaukee School Board voted June 3, 1890, for a high school to be built, and South Side High School, later known as South Division, was opened in 1898. It was located at Eighth and Lapham Streets. In 1899 Principal Arthur Burch set aside a 27-by-60 foot space in the basement as a lunchroom, and Miss Emma Stiles was in charge of preparing hot lunches for the students; each dish cost five cents. This was one of the first school hot lunch programs in the United States. In another pioneering move, it was one of the first schools to use phonographs as an instructional aid in teaching music. In 1980 this fine building met its end, but the copper-clad dome was hoisted from the tower and saved. It now resides in Milwaukee's suburb of Franklin, on the far southwest side of the city.

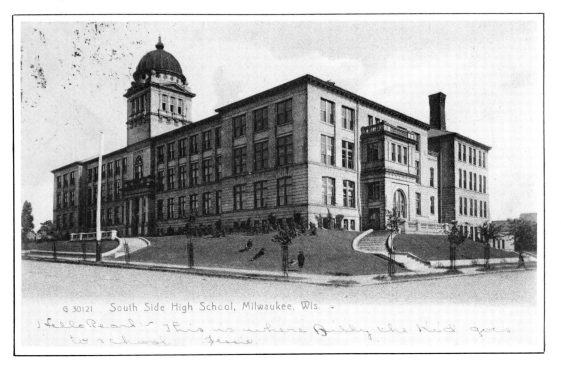

G 30121 South Side High School, Milwaukee, Wis.

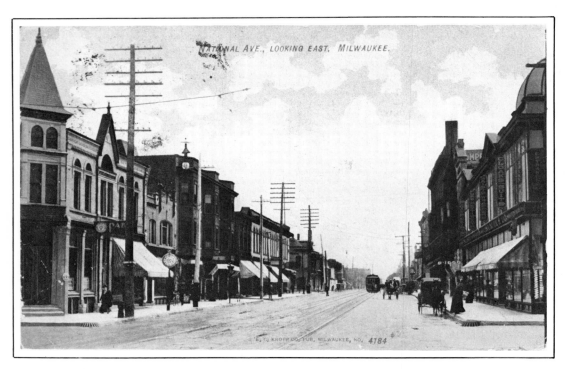

This is National Avenue at Sixth Street, looking east toward the lake, and the scene is typical of several shopping districts which sprang up around the city to service neighborhood communities. The building at the corner is a Pabst saloon and at the other end of the block (near the center of the card) was the Schlitz establishment which was a smaller version of the Palm Garden found "downtown." This building was severely gutted by fire in the early 1980's, but was restored to serve as quarters for the Milwaukee Ballet School.

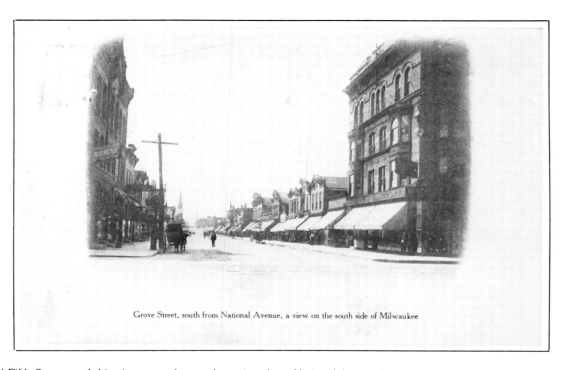

Grove Street, south from National Avenue, a view on the south side of Milwaukee

Grove Street today is called Fifth Street, and this view was taken at the point where National Avenue intersects it; most of these buildings and those in the previous card were erected in the 1870's to the 1890's. Almost all of these buildings remain and they comprise the area known as "Walker's Point." Mr. Walker was one of Milwaukee's first settlers; he started the development of the south section of the city.

131. Moonlight on Lake Michigan, as seen from Pavilion in Lake Park, Milwaukee, Wis.

As our tour of "Old Milwaukee" comes to an end we can visualize being at a moonlight band concert at Lake Park in the early days of the century, reflecting on the sights we have seen while the band plays "The Milwaukee March," composed by early-day civic boosters Luebtow and Coffey in 1926. Their deathless lines were taken from a piano roll, manufactured by the U.S. Piano Roll Company, in the author's collection; 1923 was the height of the player piano craze in America so obviously they were intent on capitalizing on that then-popular musical medium.

In my mind I can picture a city growing there
 on the shore of a lake
Where scenes to the eyesight that are pleasing
 no matter what a road you may take
But she's not only noted for beauty
 she's a leader in business too
Can't you guess the place that I'm thinking of
 if you can't I will tell it to you ...
It's Milwaukee, Milwaukee Wisconsin
 that's a wonderful city I mean
Blooming like a rosebud among thistles
 hers is a beauty so serene
She's the queen of the lakes right now
 wait till she gets her ocean waterway through
She'll blossom in full bloom like we want her to do
 Milwaukee we are betting on you. . .
Here are some of the gems of our city
 her newspapers are there with the news
Her lake front is a dandy for swimming
 fine theatres keep out all of the blues
With our parks that are really just lovely
 stately buildings so tall and just grand
I'm proud of this place that I'm talking about
 I think it is the best in the land.

[editor's note: Ouch.]

Said architect Edward T. Mix,
"Milwaukee's great skyline I'll fix
with buildings, impressive
on street corners, successive,
to impress all the visiting hix."

INDEX

Composed by Eastern Graphics in 9 point Korinna,
1 point leaded, with display lines in Korinna Bold.
Cover design by Joseph Mastrantuono